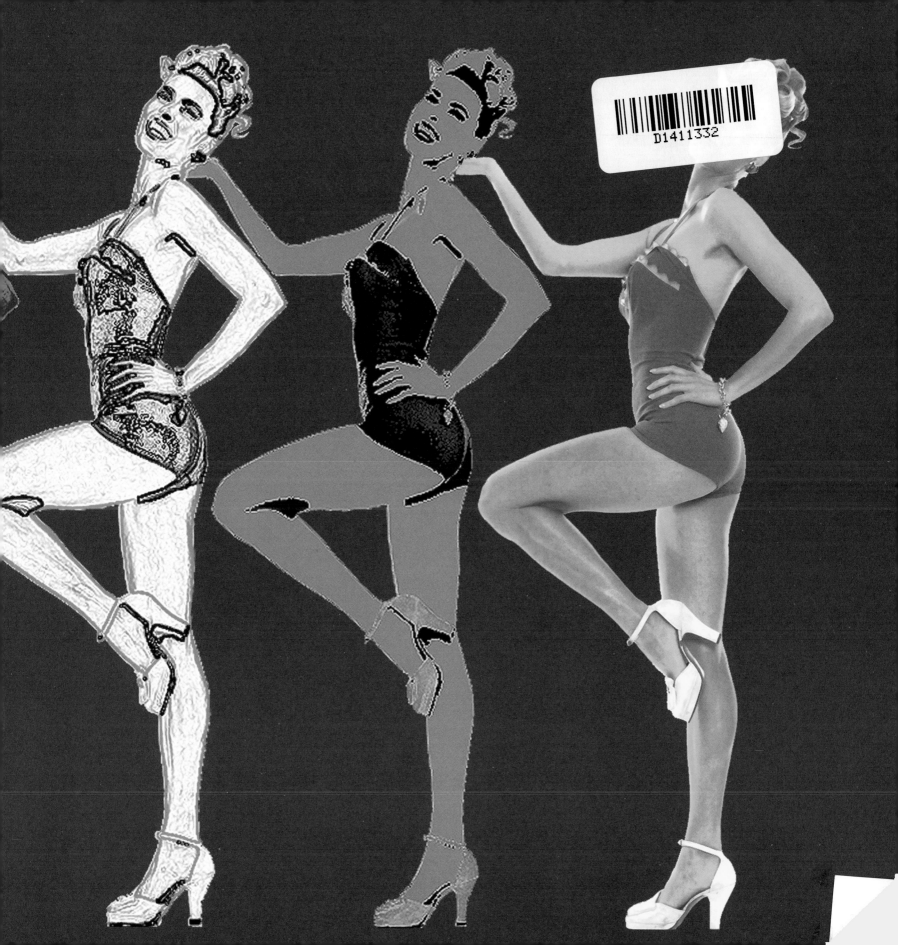

ICONS

Douglas Kirkland

ICONS

CREATIVITY WITH CAMERA
AND COMPUTER

CollinsPublishersSanFrancisco

A Division of HarperCollinsPublishers

To Françoise
with love and thanks for all the support

————

First published 1993 by Collins Publishers San Francisco
1160 Battery Street, San Francisco, California 94111

Produced by Welcome Enterprises, Inc.
164 East 95th Street, New York, New York 10128
Designer: **Nai Chang**
Editor: **Hiro Clark**

In association with the Center for Creative Imaging
51 Mechanic Street, Camden, Maine, 04843

Film separations made by High Resolution, Inc.
4 Knowlton Street, Camden, Maine 04843

Printed and bound in Singapore by Tien Wah Press
First Edition

Library of Congress Cataloging-in-Publication Data
Kirkland, Douglas, 1934–
Icons : creativity with camera and computer / Douglas Kirkland.
p. cm.
ISBN 0-00-255227-2 : $27.95
1. Photography–Special effects. 2. Photography–Data processing.
3. Image processing.
TR148.K54 1993
770' .92–dc20 92-45207
CIP

Endpages: **Vendela,** a supermodel of the '90s, presents a chorus
line of computer effects starting with the unmodified image on the far right.
Pages 2–3 and 4–5: **Judy Davis**

CONTENTS

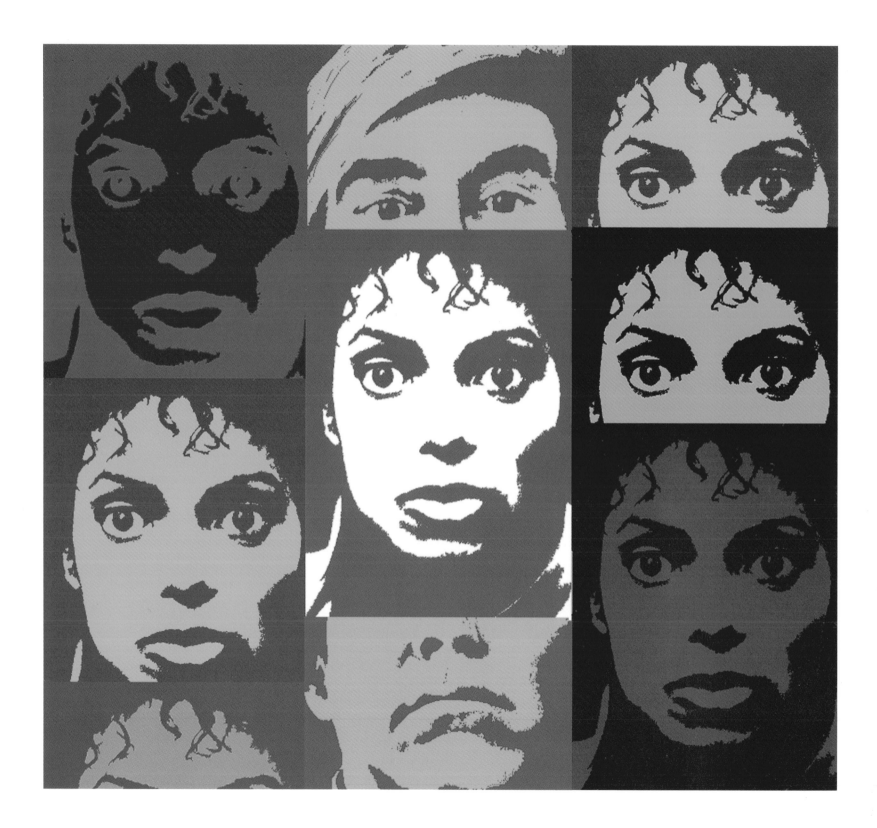

INTRODUCTION

The era of computer-modified pictures is here, and photography will never be the same.

I often wonder what images Andy Warhol, with his '60s spirit, might have invented if he had had modern computers at his fingertips. Where could his inspiration have taken us? At the time Warhol was revolutionizing the New York art scene, people often became angry at the mention of his name. They thought of his *Campbell's Soup Cans* and of *Sleep*, his eight-hour art film of a man sleeping, as nothing but giant cons. I can remember loud, protesting voices saying: "Regular people don't get taken in that easily." Others ignored him, laughed at him, or revered him as pure genius. In different ways they were all right. But no matter how you felt about him, you knew his name and what he looked like. Andy Warhol had successfully made himself into *the* personality of the day, the high priest of Pop, an icon.

The truth is, Warhol never expected us to take everything he did or said as gospel. He was testing himself and playing with us. In the probing, stimulating, experimental, psychedelic days of the '60s, everything was open to question and up for grabs. So often I heard people self-righteously state that they wanted to try everything once. Though this sounded very "sexy," a few poor souls never found their way back. It was a period when youth felt that it had discovered the meaning of life for the first time in the history of the human race, and the people who said "Let it all hang out" lived life to the hilt. Creativity in all forms was celebrated. How quiet and complacent most of the arts seem by comparison now.

Although computers did exist at the time Warhol started his frenzy of photostatting, painting, silk-screening, photographing, publishing, and filmmaking, the machines were huge, unfriendly monsters intended for abstract scientific exploration or business use rather than to facilitate an artist's free expression. I got my first computer in the early '80s. At twenty-eight pounds, the Osborne was referred to as a "portable," but it was really more a "luggable." The random-

Michael Jackson with Friend is an homage to one of the principal architects of the Pop art movement, Andy Warhol. Not long after I had photographed Michael on the set of his music video *Thriller*, Andy created a *Time* cover using a similar picture of Michael I had made.

access memory was only 64 kilobytes and the internal disk drive 92K. By today's standards, this seems unimaginably limited. The disk space employed in creating this book, for example, was 2.5 gigabytes—the equivalent of nearly 30,000 Osborne floppy disks!

A lot has changed since a decade ago. Today's personal computers are more sophisticated, but at the same time they are simpler and easier to use. The computer, which only yesterday seemed reserved for the hands of an elite few, has become accessible as a friendly collaborator to people such as myself. It is difficult to describe the artistic emancipation that this strange machine brings. Sitting in front of my computer, I feel as if I have been given creative weightlessness. Electronic impulses instantly transform my images into any variation or carry them to any place I desire.

New Fears, New Realities

Some traditionalists in photography feel offended by what they see as the ultimate corruption of their art, while more adventurous individuals celebrate the birth of a completely new art form. Both are right. When colleagues ask why I would want to manipulate my pictures with a computer, my answer is simple: photography has undergone various forms of manipulation since its inception. Hasn't the number of times a darkroom tray is rocked always made a difference? The legendary W. Eugene Smith was reputed to have worked for several days making the perfect print in his darkroom. Was this not image manipulation?

Others have confronted me with the question of how I would feel if someone took my photographs and distorted them into something completely different from what I had intended them to be. Or I am asked how it would be if little bits of my images were scattered into other people's work, without compensation or acknowledgment. This would, of course, be a world that none of us wants, not only because of the ethical considerations but because today so many of us make much of our living from usage fees. Also, a myriad of legal concerns arises in the event a third party improperly uses material, as happened a few years ago, when a major publication was sued for splicing the head of Oprah Winfrey onto the shapely body of Ann-Margret. It is not inconceivable for a photographer to become the target of such a suit, even if he or she has no knowledge of the misuse.

And there are many people whose occupations are threatened by the

computer's advance. As more photographers develop the ability to retouch on the Macintosh and other personal computers, what will happen to the highly skilled traditional artists who have spent their lives using brushes, airbrushes, and etching tools along with their dyes and paints? If they are incapable of making the transition to the computer age, they will be out of work, something they never dreamed would happen. At the same time, who would suggest the photographer's job is completely safe? Many capable art directors could replace the photographer by using the new digital camera.

There is no saying that people will be able to survive or move ahead if they cannot master the required new skills. The realities of the computer age will spread into almost every occupation and throughout the world as we move into the twenty-first century.

Creativity with Camera and Computer

What do we call these new electronic images? Are they modified photographs, or have they become something else? In my opinion, the computer-modified picture should be considered an entirely new medium. So let's rename this digital image. Since the process starts with light that is converted into electrical digits for computer manipulation, we could call them *digigraphs,* or *photo digigraphs.* Perhaps this would allow the traditionalists to feel that their hallowed process has been less violated. In any case, it seems better to put these questions of photographic purity aside so we can simply enjoy the results. Belaboring the issue only reminds me of the question "Is photography really art?"—a debate that raged fifty years ago. Instead, let's concentrate on our new aesthetic freedom.

In fundamental terms, the process begins as follows: an image is put into the computer either by scanning an existing transparency, as was done for this book, or by taking photographs with a digital camera, which can feed the electronic images directly into the computer. The picture of Catherine Deneuve was the very first photograph I modified on the computer. Its creation was as simple as it gets; I scanned an 8" x 10" copy transparency using a video camera connected directly to a Macintosh LC computer, a rather unusual procedure at the time. The final composition was created using a watercolor filter with Adobe Photoshop. At the service bureau where I brought my floppy disk, I encountered many condescending looks, since they felt that no one who was serious could possibly expect a "minuscule" 726K file to produce anything

worthwhile. The result, however, was more than satisfying and clearly revealed the limitless potential of combining the abilities of camera and computer with the artist's imagination, not to mention a little determination.

The computer methods used are as varied as the results. Images created by other people with the same equipment I use will probably bear little resemblance to my work. Though I thrive on this new technology, I hardly consider myself a computer virtuoso or a hacker. I am a photographer using the basics to go where photography alone has not previously allowed me to venture. It may sound odd, but I feel as though the computer is the other half of the camera I've been searching for since I began my photographic career more than thirty years ago. I have always taken great pleasure in shooting pictures, but aesthetically the process has often seemed limited. How frequently I have wanted to make the sky bluer, the grass greener, or, out of sympathy, my subject's face smoother. As a photographer, I manipulate the medium to the best of my ability, but nothing I can do manually touches what is possible using skill and judgment at the computer. With it I can carry my results further than all the darkrooms, filters, and lights put together, although they too remain very important to me. With the computer my methods are frequently unorthodox, but I have never wanted to get so technically intertwined with the machinery that I lose sight of my real goal: a visual flight of fancy.

For anyone from a traditional art background, the tools presented on the screen might seem surprisingly familiar: brushes, pens, pencils, erasers, airbrushes, and an endless palette of colors. You can tell the machine to fill in an area with color or a pattern, and then, what might take a painter hours of brush strokes is done instantly. If you decide the results are not aesthetically pleasing, you can keep changing them at a fantastic rate, until you are satisfied. With some programs, you can actually select a *theoretic paper surface*—the coarseness or smoothness—and that effect is instantly transferred to the image. Other programs provide an "undo" command that allows you instantly to cancel anything that you have just done and start over. Knowing this command exists encourages a freer form of experimentation than the commitment of brush strokes to paper or canvas. Computer guru David Biedny once joked: "I've often wished that I had one of those for my life."

Though entranced by the possibilities the new technology offers, I find it is very important to know when to say "No, this does not work," and then to begin again. Many of the images in *Icons* are the product of several reevaluations, sometimes maintained as works in progress over many months. I would

finish them, live with them, and then decide either to keep them as part of the collection or to go back to the drawing board. Very often, time would warp in frightening degrees. It could be hours before I would shift my eyes away from the screen. The next morning I might feel ecstatic when I saw what I had done, or I might see nothing but embarrassing trash.

Dreaming the Future

In 1966, I was the special photographer for Stanley Kubrick's film *2001: A Space Odyssey*. During that period I spent time with both Kubrick and one of this century's greatest writers of science fiction, Arthur C. Clarke. The movie soundstages were a living laboratory of the future. Every device—from the Pan Am Space Shuttle, the centrifuge machine, and the HAL 9000 computer to the photographer's still camera and the pocket calculator—was fantastic. As we glide toward a future that once seemed impossibly far away, much of what this film foreshadowed is now either with us or is surprisingly close.

Computers that can respond to spoken commands will unquestionably be in common use by the year 2000. Simple versions already exist. Fortunately, I don't believe they will be as cantankerous as HAL, although they may increasingly develop personality traits as we demand more from them. Cameras of the future will be small, ergonomic, advanced digital mechanisms easily capable of shooting by moonlight or in other low-light conditions, and will offer the simple option of making either stills or movies at the turn of a switch. Stills will increasingly come from high-resolution "grabs" from the camera's advanced video stage, and will be made after the fact. So much for the mystique of the photographer's sense of the decisive moment.

As for the artistic re-creation of our images in the computer, we have only begun to discern the great spectacle that awaits us. Imagine bigger-than-life holographic images that glow with life as they float across our walls, moving into any configuration we desire. If we choose, we will live within endless mood-forming facades of the seas, the skies, spring blossoms, distant planets, or majestic human forms. Increasingly, these images we create will live around us rather than being captured in the pages of a book or projected onto a motion-picture screen.

When that day comes, I am sure many people will look back with interest on the present era and think of it as the primitive, exciting beginning of the new digital age.

—DK

The equipment used to create the final images in this book was relatively simple:

—Macintosh IIci computer with 8 Mb (megabytes) of RAM (random-access memory) and an internal 160 Mb hard drive in addition to the standard 1.4 Mb floppy drive
—Macintosh System 7
—Radius Rocket board, with 32 Mb of RAM, which greatly accelerates data processing
—SyQuest removable cartridge drives (44 Mb and 88 Mb) for storage
—Sony magnetic optical drive (650 Mb) for storage
—Wacom Digitizing Tablet (6" x 9"), which uses a pressure-sensitive pen and affords superior drawing control compared to a conventional mouse
—SuperMac Technologies color monitor (19")
—Adobe Photoshop (Macintosh version 2.0.1), perhaps the premier photo-retouching program available for Mac users today

For each finished image, I scanned the original photograph an average of two or three times. In most cases, rescans were performed in the effort to improve image quality. I used drum scanners, which are at the high end of scanning technology, to make the images of Judy Davis (pages 4–5) and Dustin Hoffman (page 16), among others. Close behind in quality are the scans of transparencies made on the Leafscan 45, which handles transparencies larger than 35mm, and the Nikon LS-3510AF and Kodak RFS 2035, which are for 35mm only. In general, the file size of each scan was approximately 8 Mb, but in certain cases they ran as large as 19 Mb (Grace Jones, pages 42–43) or as small as 726K (Catherine Deneuve, page 15), the latter being unusually small for a color scan.

If you are just beginning to work with computers and images, you will immediately face the need for large amounts of disk storage space and computer speed, along with capacity (RAM). Working on graphic images is quite different from word processing. A page of text might result in a file of only 10K, but it is not inconceivable for a single picture—also only one page—to take up as much as 10 Mb, or a thousand times the space. A few complicated graphic files can very quickly eat up a 40 Mb, or even an 80 Mb, internal hard drive—a good reason to utilize a removable cartridge drive for pure storage. Larger files also require more time for the computer to manipulate, which is why one of the primary aims of computer technology is to increase the power and speed with which data can be handled.

The basic necessities for manipulating scans of images on a computer include the computer itself, such as an Apple Macintosh, a 40 Mb hard drive, 4 Mb of RAM, a monitor (preferably color) of adequate size for viewing graphics, and an image-retouching program such as Adobe Photoshop. As much research as possible should go into putting together a setup that accommodates personal budget, level of expertise, and the results desired. The array of hardware and software available is expanding at a tremendous pace, and no one setup is appropriate for everyone.

CATHERINE DENEUVE sat in a frigid train station in Vienna, as delicate snowflakes fell late into the night. This photograph was the first image I modified using Adobe Photoshop on the Macintosh, and the result has become a personal favorite.

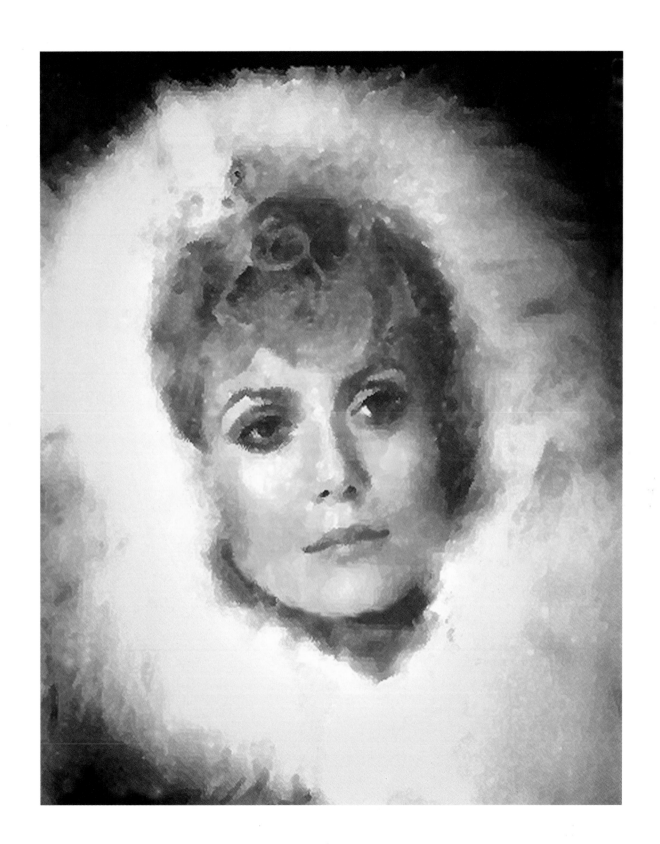

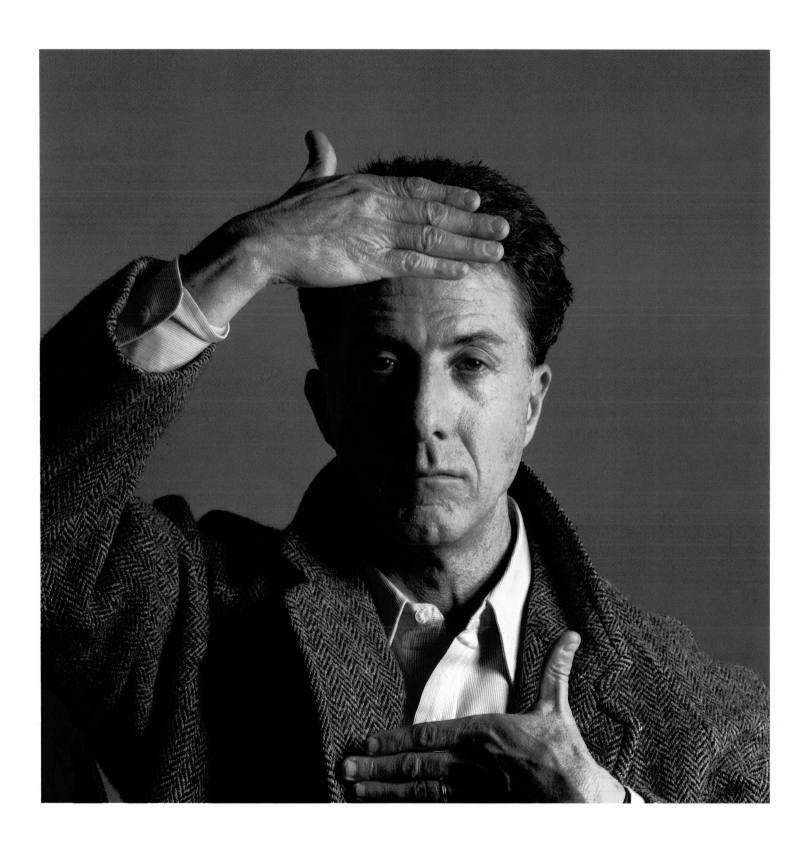

OPPOSITE: DUSTIN HOFFMAN has the ability to sense the camera's every move and to relate to it as though it were another person. In this case, he communicated to me as Raymond Babbitt, the autistic protagonist of *Rain Man*.

DREW BARRYMORE took great delight in teasing the camera. After changing a roll of film, I looked up to find her dancing up and down and playfully laughing, "Aren't they nice?" while her breasts shook atop her skintight dress. She was a delightful child celebrating life in a woman's body.

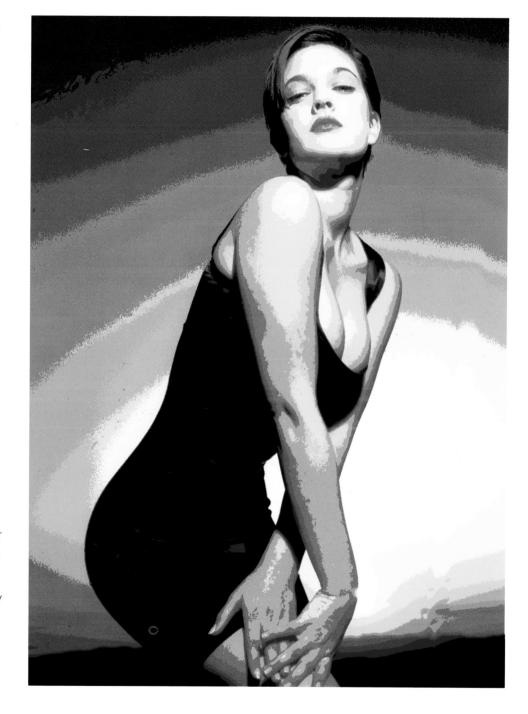

ROBERT DE NIRO is the actor for whom I have the greatest respect. Having experienced his performances as the crazed Travis Bickle in *Taxi Driver*, the tortured Jake La Motta in *Raging Bull*, and the kindhearted bounty hunter in *Midnight Run*, I wonder: "Who is he, really?" Not surprisingly, I spent more time on this image than on any other, reforming it countless times over a period of several months.

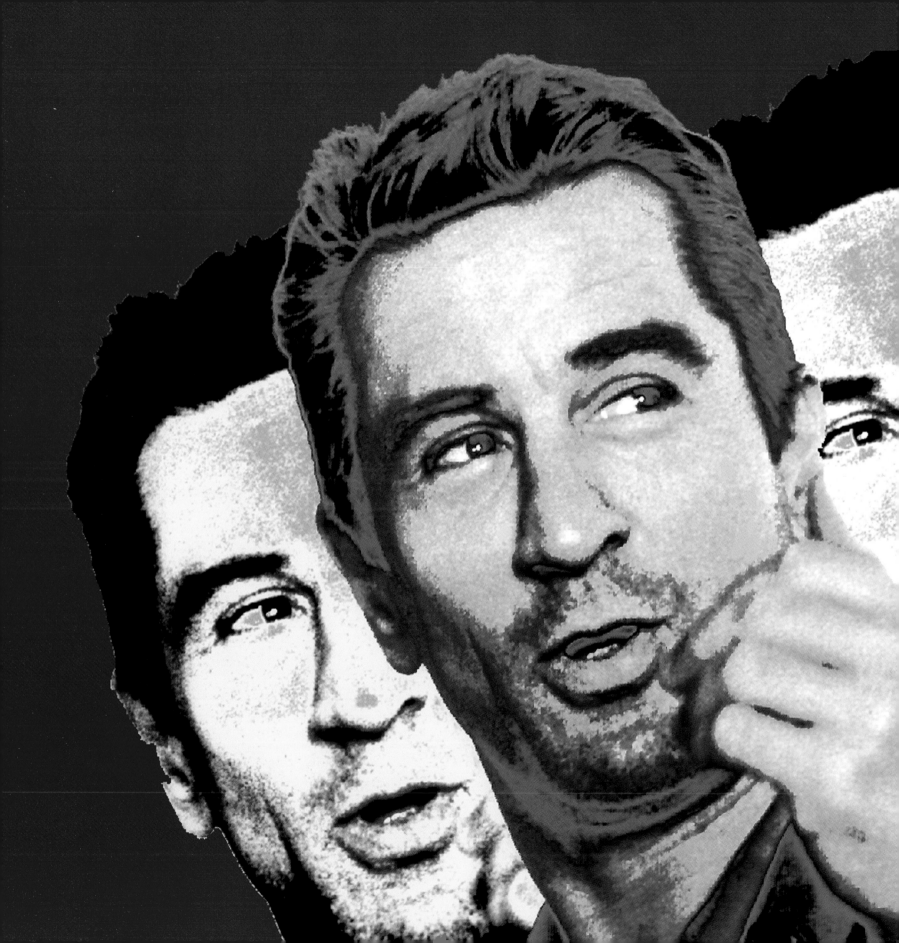

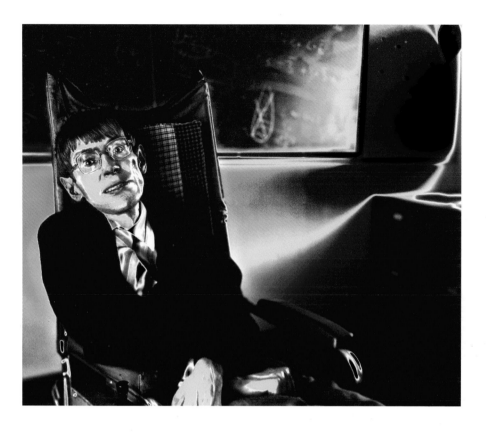

STEPHEN HAWKING, the physicist, is considered
by many to be one of the greatest minds of all time,
perhaps even rivaling Albert Einstein. And yet years
went by, and Dr. Hawking wrote a best-selling book,
A Brief History of Time, before anyone was interested
in publishing my pictures of him. Before that, editors
saw only the disturbing cosmetics of a body crippled
by a devastating disease.

OPPOSITE AND OVERLEAF, LEFT AND RIGHT: MARILYN MONROE knew the same uncertainties that most of us experience. The woman with the innocent face wanted nothing more than to please, to be accepted, and to have a successful career. When she was late coming into a room, it was usually because she was on the other side of the door trying to bring herself as close to perfection as she knew how. Sometimes, she'd worry about being too fat, and after losing weight, she'd worry that her breasts seemed too small.

Marilyn once told me the following story: "When I was young and worked in a factory, I'd go to the movies on Saturday night and sit alone in the back row. If the movie was good, really good, it would carry me through the entire week back at my job. That's what movies should do; that's what they should be all about."

And that is what she hoped her movies would do for us.

Marilyn Monroe's image on the opposite page was changed minimally. Using Adobe Photoshop, I dodged, burned, and cropped it very much in the tradition of darkroom printing. However, I modified the images on the following pages using a wider variety of the tools available in Photoshop. I'm often surprised by how far technology has brought us since I took the original photographs in 1961.

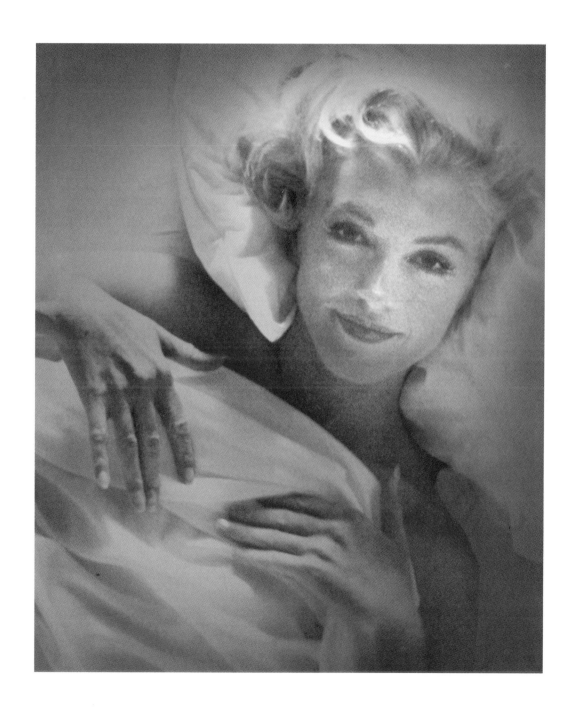

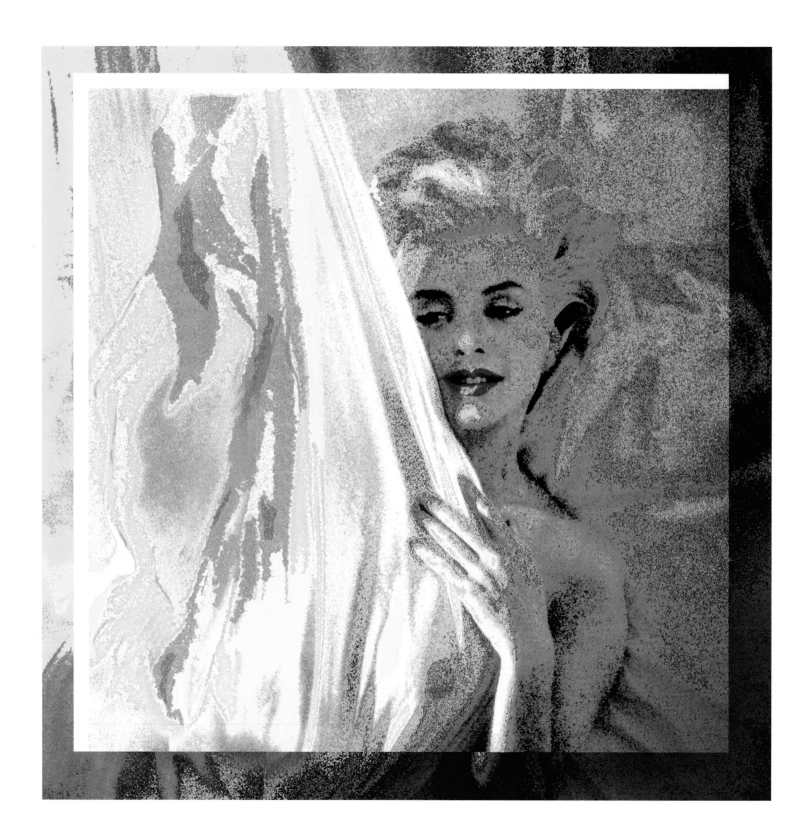

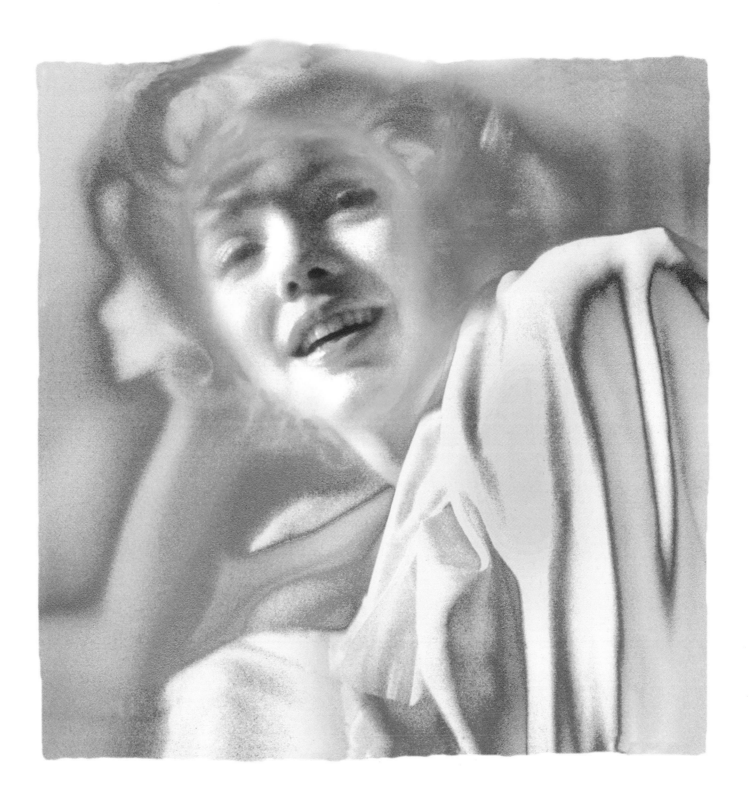

KIM BASINGER walked into my studio and, in her
down-home Georgia accent, demanded to know how
long the session was going to take. At the beginning of
my career, I might have spent up to a month on an
assignment, but in this case it was over in less than an
hour. Kim giggled with glee as she looked at her
Polaroids, saying how great it was that I was "so fast."
Then she asked if she could bring Prince the next day to
take some personal shots. But this never happened. We
waited for several hours with the requested chilled white
wine. Then a call came with the apology: "Prince
wasn't feeling well."

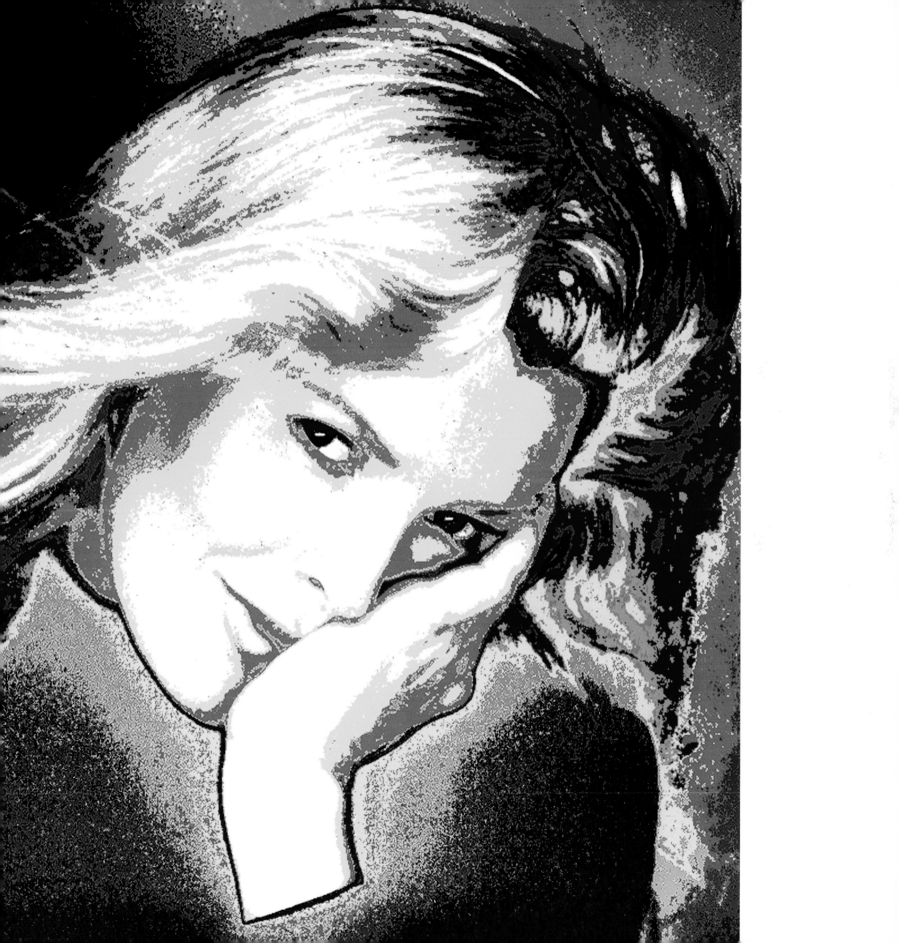

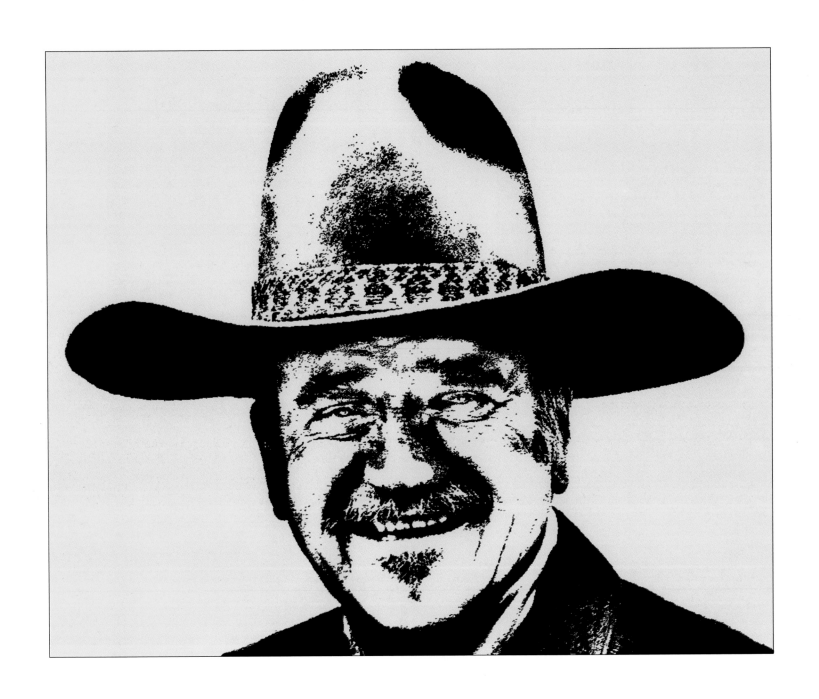

ABOVE: JOHN WAYNE

OPPOSITE, CLOCKWISE FROM TOP LEFT: ROBERT MITCHUM, GEORGE BURNS, BOB HOPE, AND KIRK DOUGLAS

As I look back over the years spent rubbing shoulders with the great ones, these are the faces that stand out. They are the greatest of them all.

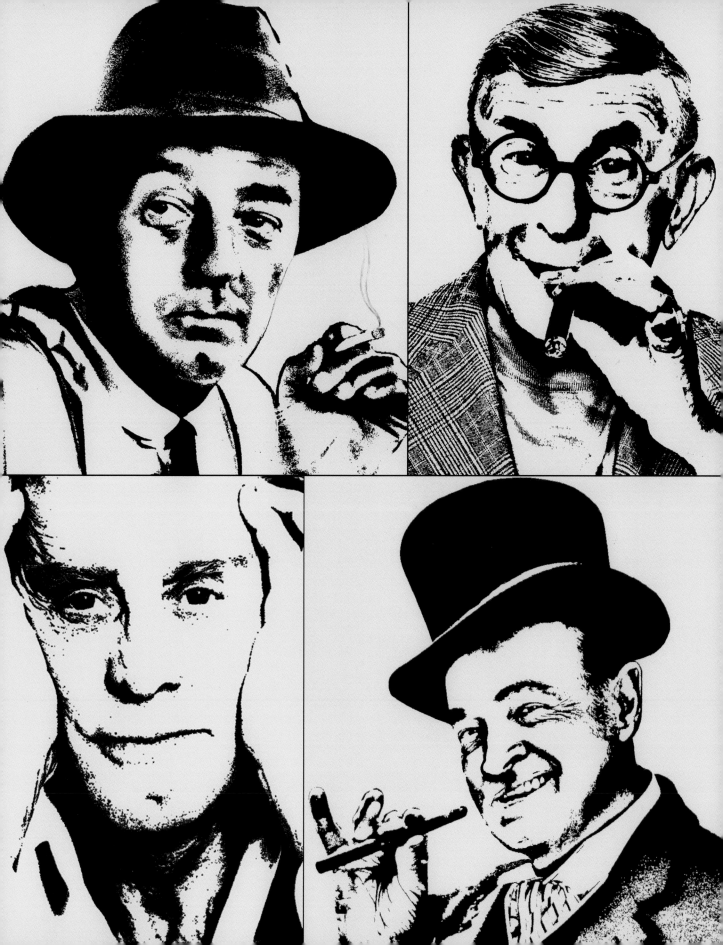

WARREN BEATTY has always struck me as a different kind of Hollywood animal, one who doesn't think like the others. On a personal level, I have never found him to be egotistical or removed; rather, he is hardworking and completely aware of everyone around him. When the establishment refused to give a real push to his movie *Bonnie and Clyde*, Beatty is said to have taken the reels to the theater operators himself and convinced them to show it, leading to the film's success.

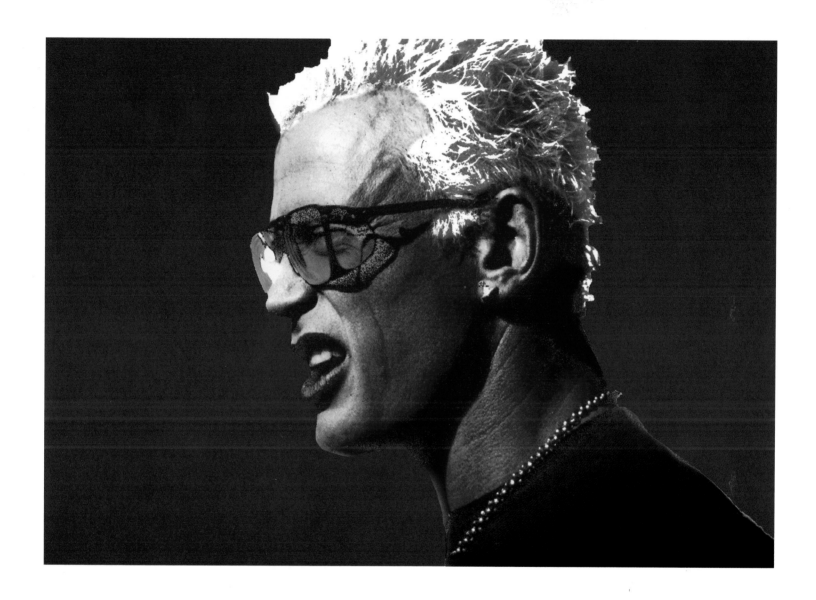

BILLY IDOL epitomizes the black-leather-clad, motorcycle-riding, bad-boy pop star of the '80s. Some suggest that his celebrity goes beyond his talent. One thing is certain: the Idol has made himself into an icon.

CHER is someone I have photographed through numerous incarnations as the whimsical public went overnight from loving her passionately to disliking her, and then back to loving her again. Remaining an icon in our society has always been a perilous affair, especially today, with our short attention spans and sound-bite mentalities.

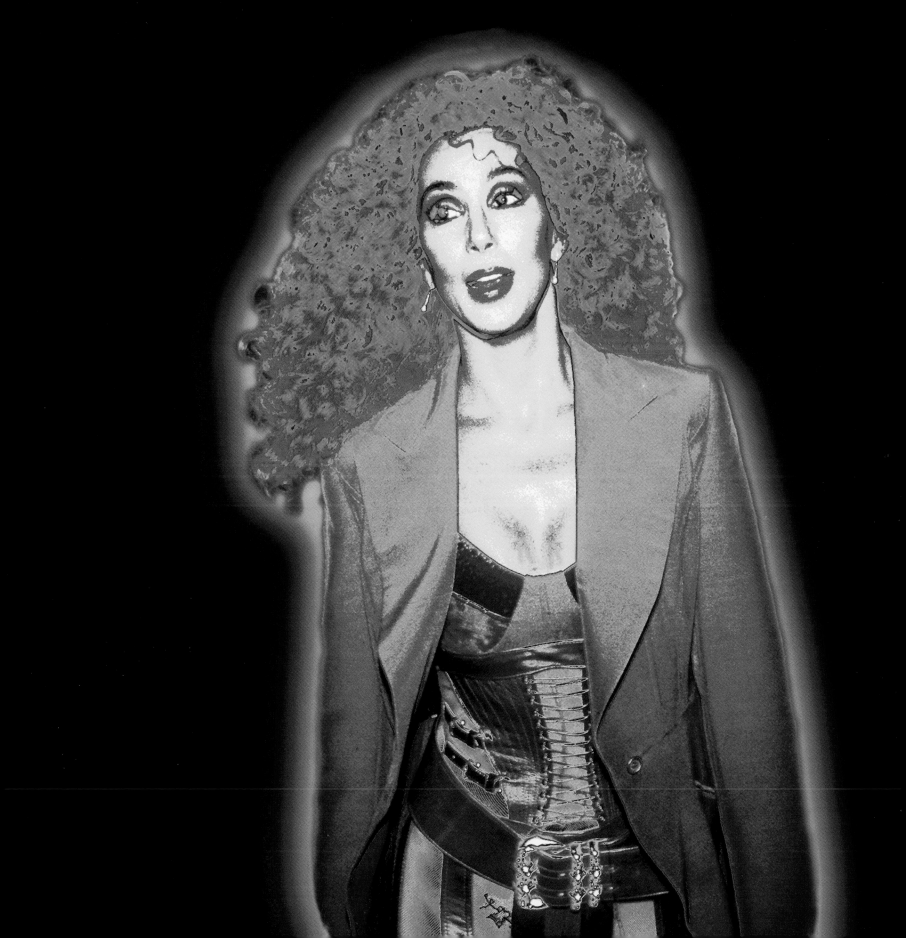

MICHAEL JACKSON was a paradox to me as I photographed him on the set of *Thriller*. The contrast between his gentleness in real life and his wildness on camera was fascinating to behold. The camera can also transform a person into seemingly different individuals by the subtle turn of an angle or the adjustment of a light. With the computer, these changes become even more dramatic. These two images of Michael as a werewolf, for example, were both created from the same photograph.

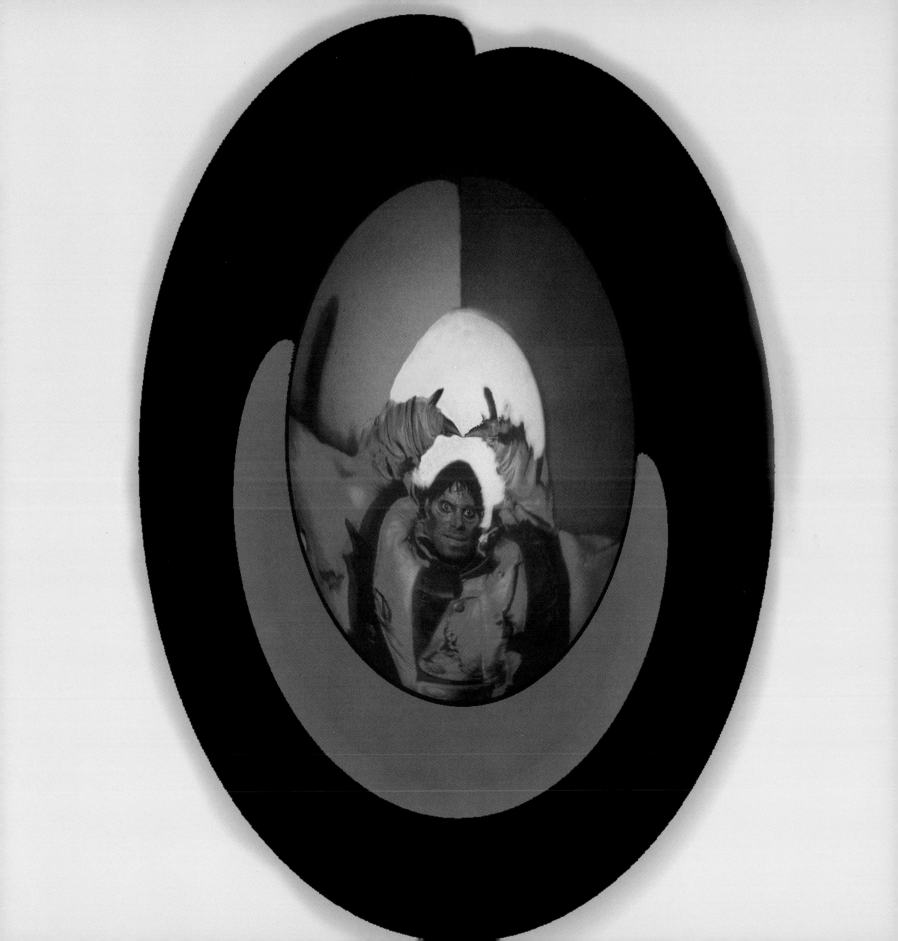

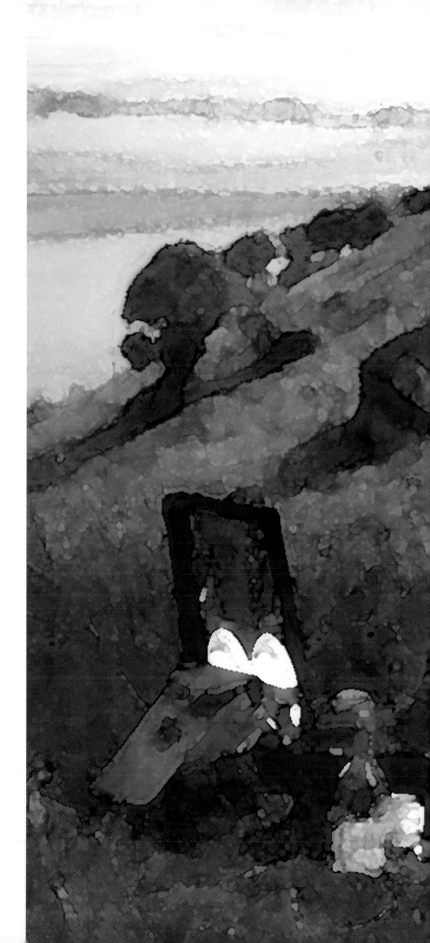

OUT OF AFRICA, WITH MERYL STREEP AND ROBERT REDFORD, was set on location in the pastoral plains and hills of Kenya. The company was based in Nairobi but often headed out on safari, like a band of affluent Range Rover gypsies, to shoot scenes for the film. As the days turned into months, the sight of elephants, giraffes, and wildebeests began to seem ordinary. Most of us did not truly realize where we had been until long after we had returned home.

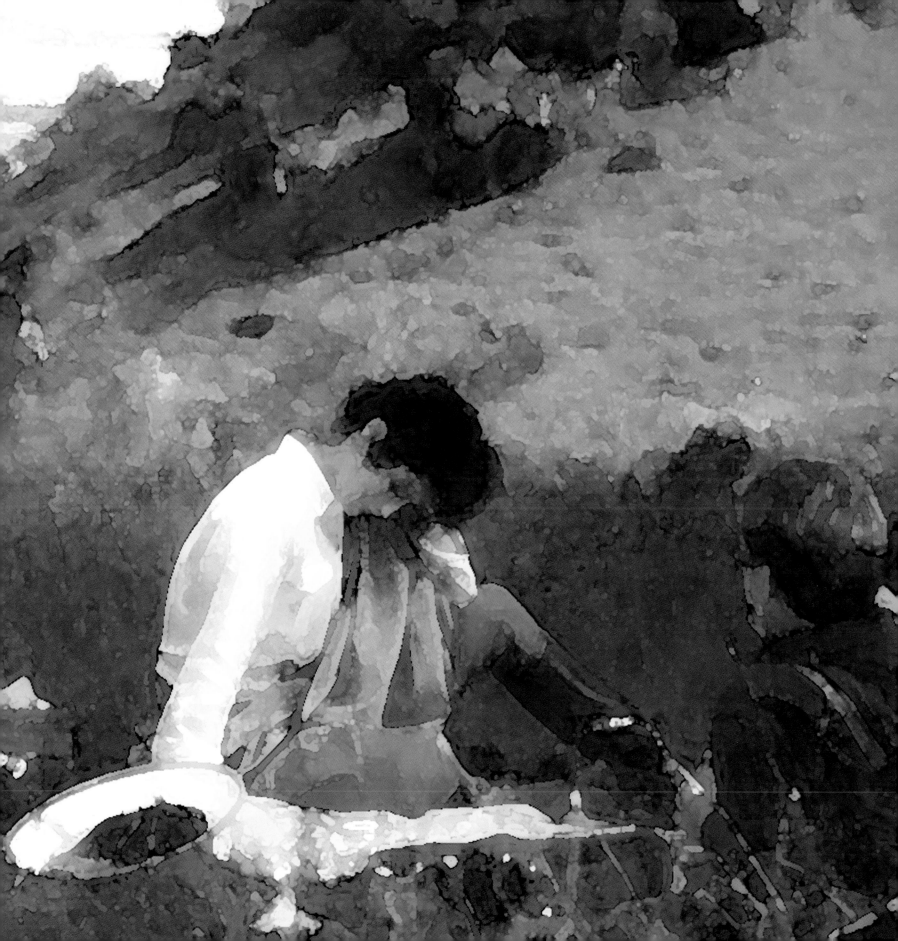

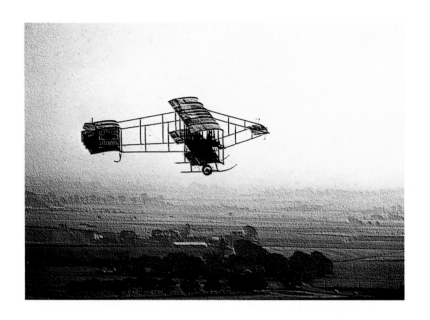

LEFT: THOSE MAGNIFICENT MEN IN THEIR FLYING MACHINES was one big toy factory for me. Even though it was a comparatively low-budget movie, the British producers had gone into various museums to find original blueprints of early aircraft, then had meticulously recreated them so they could fly.

Imagine what a thrill it was for a kid like me, who had loved planes all his life, to sit there in the open side of a turbo-prop chopper and chase those babies with his lens.

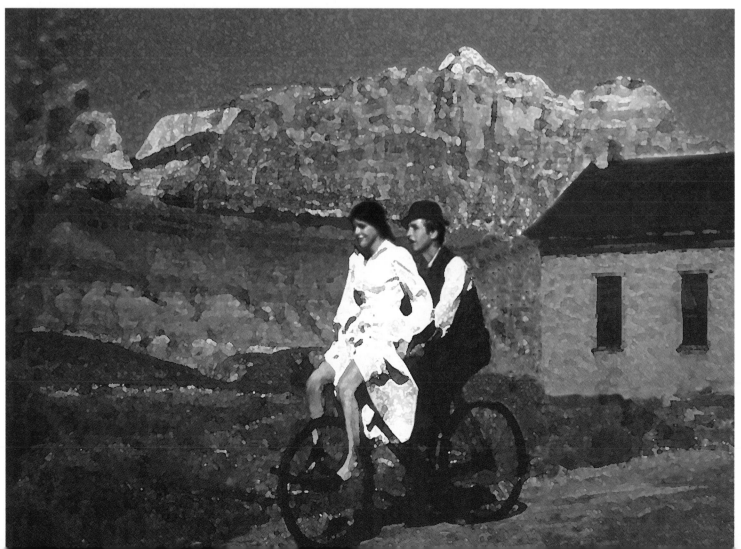

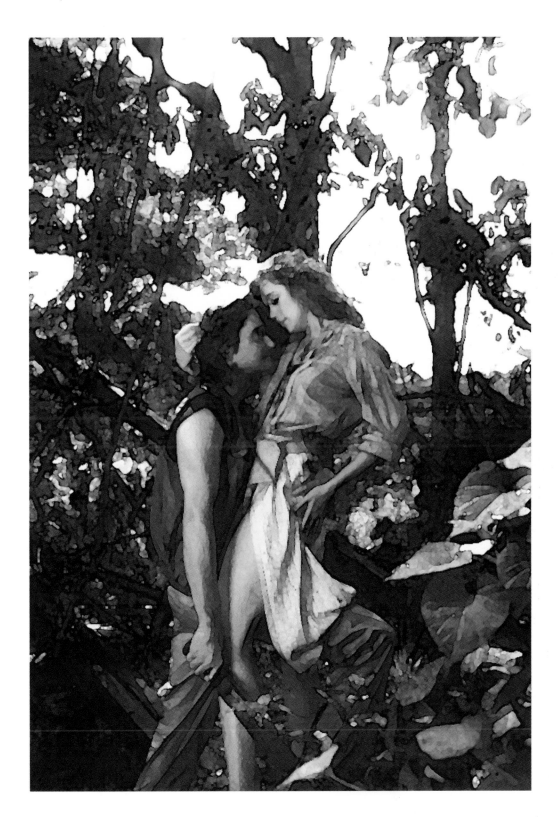

OPPOSITE: BUTCH CASSIDY AND THE SUNDANCE KID was shot mostly on location in Utah. The way this scene was described to me—a wobbly bike ride to be cut against music—it did not sound particularly interesting. The song turned out to be "Raindrops Keep Falling on My Head," and the scene with Paul Newman and Katharine Ross one of the most memorable in the movie.

LEFT: ROMANCING THE STONE, WITH MICHAEL DOUGLAS AND KATHLEEN TURNER, brought me to Mexico before principal photography began. The plan was to shoot publicity stills, but Michael took the opportunity to begin exploring the characters and their relationship. During that period, not only the jungle was hot and steamy.

OVERLEAF: THE CHARGE OF THE LIGHT BRIGADE was a United Artists spectacle about the Crimean War. Ironically, a large portion of the cast was from the Turkish army. Dressed up in nineteenth century uniforms, they charged over the same lands that had originally been disputed.

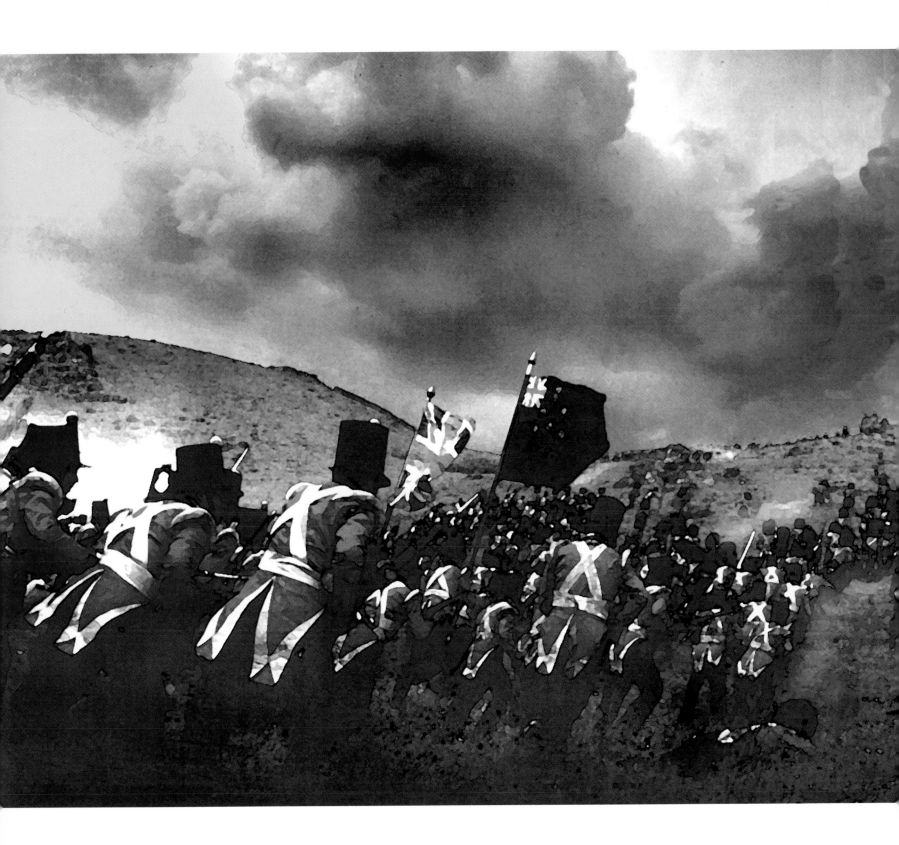

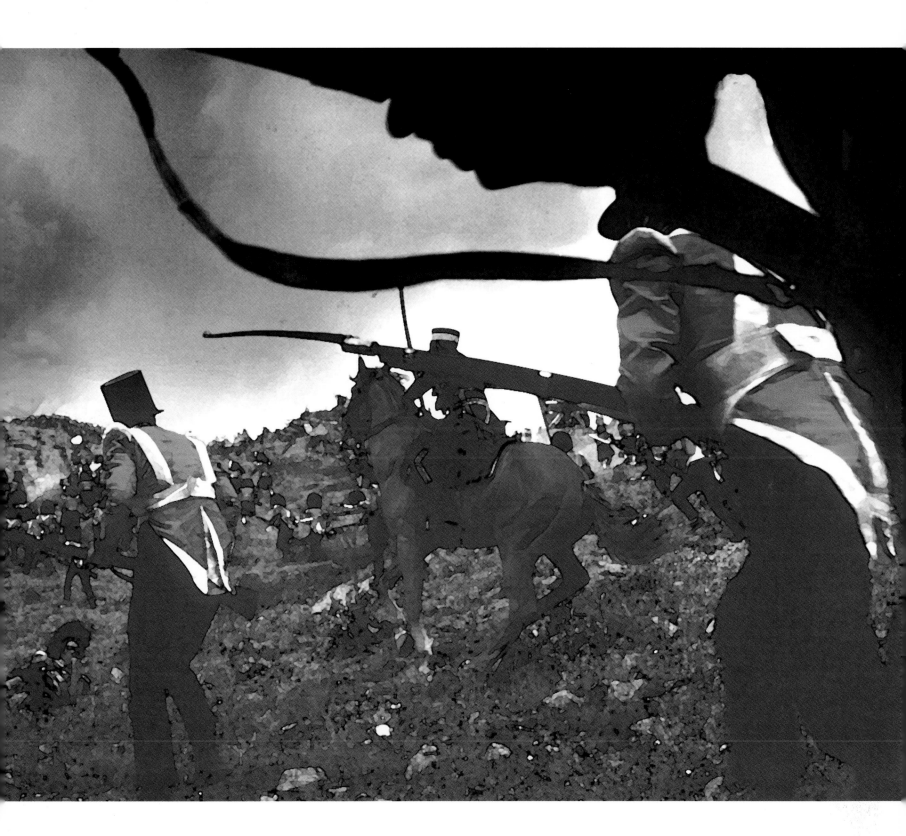

KEITH HARING got together with GRACE JONES
to decorate her for a scene from *Vamp*, a very
unmajor motion picture, in which Jones burns up
the screen as a stripper-vampire. As you can see,
Haring was allowed to paint anywhere he liked
on Jones's body.

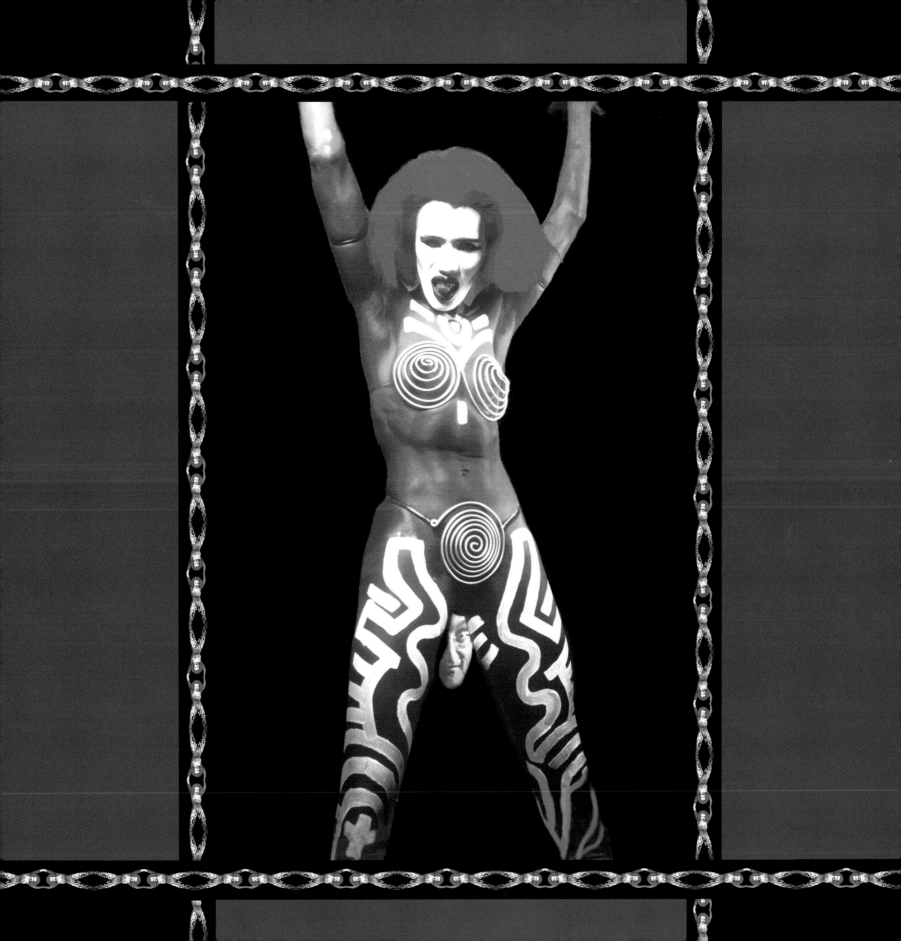

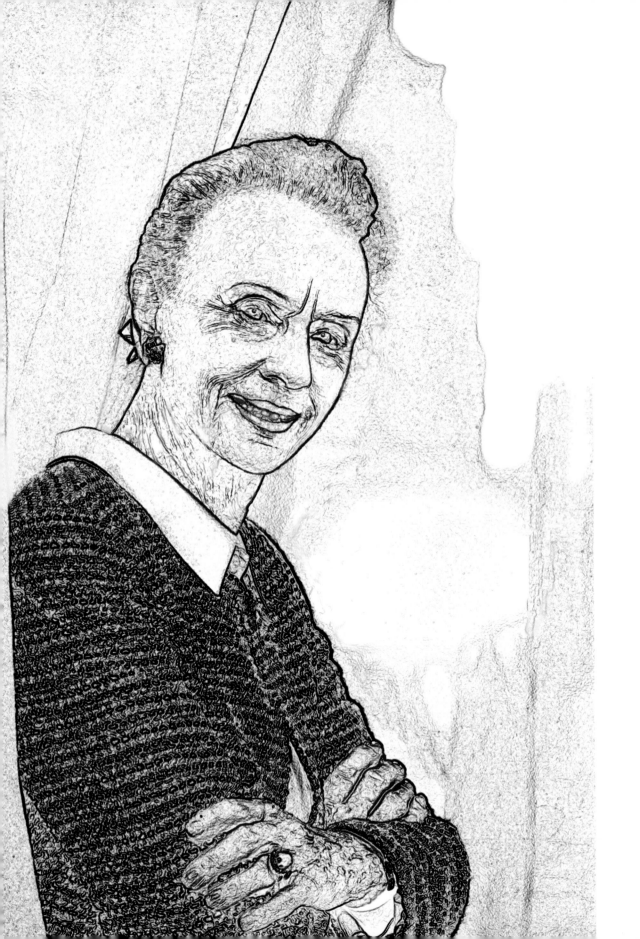

LEFT: JESSICA TANDY confessed surprise to me at all of the attention she was receiving in her early eighties. She lamented: "I just wish they'd get it all over with, so that Hume and I could go back to our normal lives."

OPPOSITE: BETTE DAVIS was one of the most strong-willed and powerful superstars Hollywood has ever known, yet, in spite of my preliminary anxieties, my day of photographing her worked out well. We finished by sitting outside and sipping white wine as the lights of Hollywood came on, and she whimsically recalled stories about people and places she had known in "that town down there."

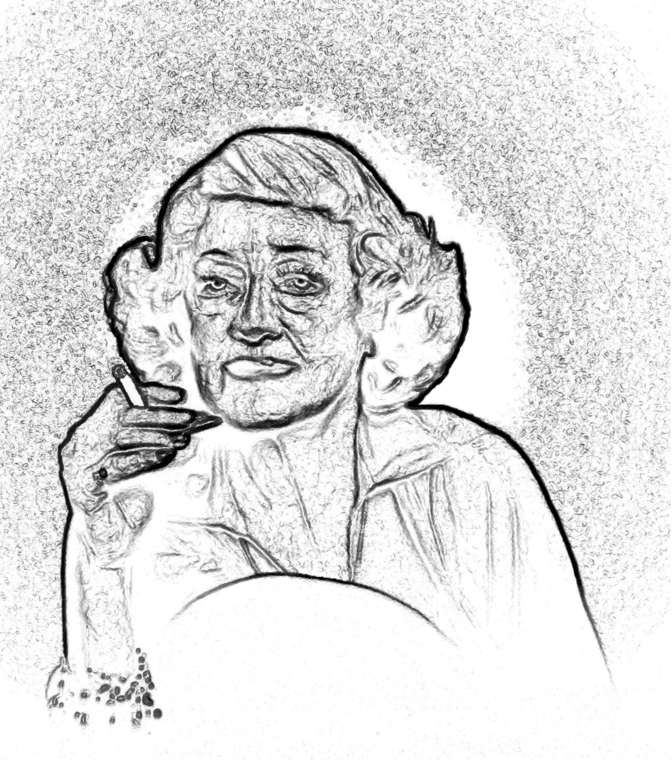

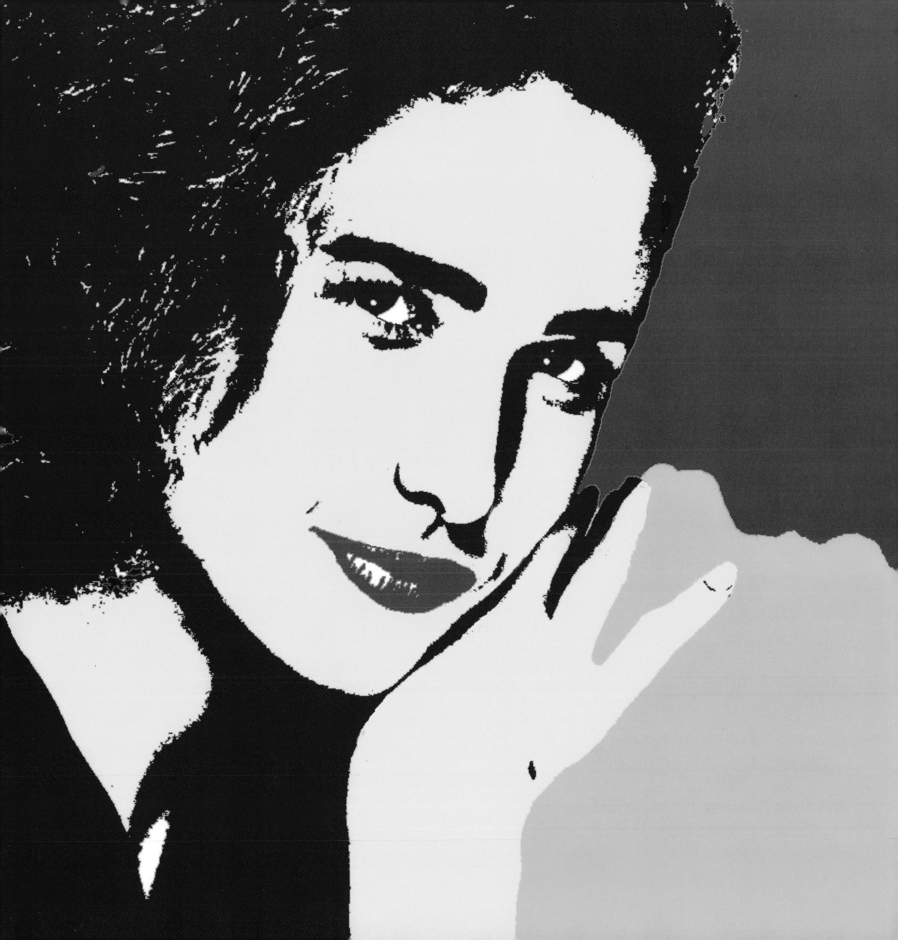

OPPOSITE: ANDIE MACDOWELL was a trendsetting model of the '80s before she vaulted onto the big screen as an actress. A top cover girl's potential seems almost unlimited these days.

OVERLEAF LEFT, CLOCKWISE FROM TOP LEFT: ELLE MACPHERSON, CAROL ALT, IMAN, AND CHRISTIE BRINKLEY
OVERLEAF RIGHT: CINDY CRAWFORD

Here are some of the supermodels whose images have grown to control our lives, as they dictate, in such an appealing way, what we should do, think, and buy.

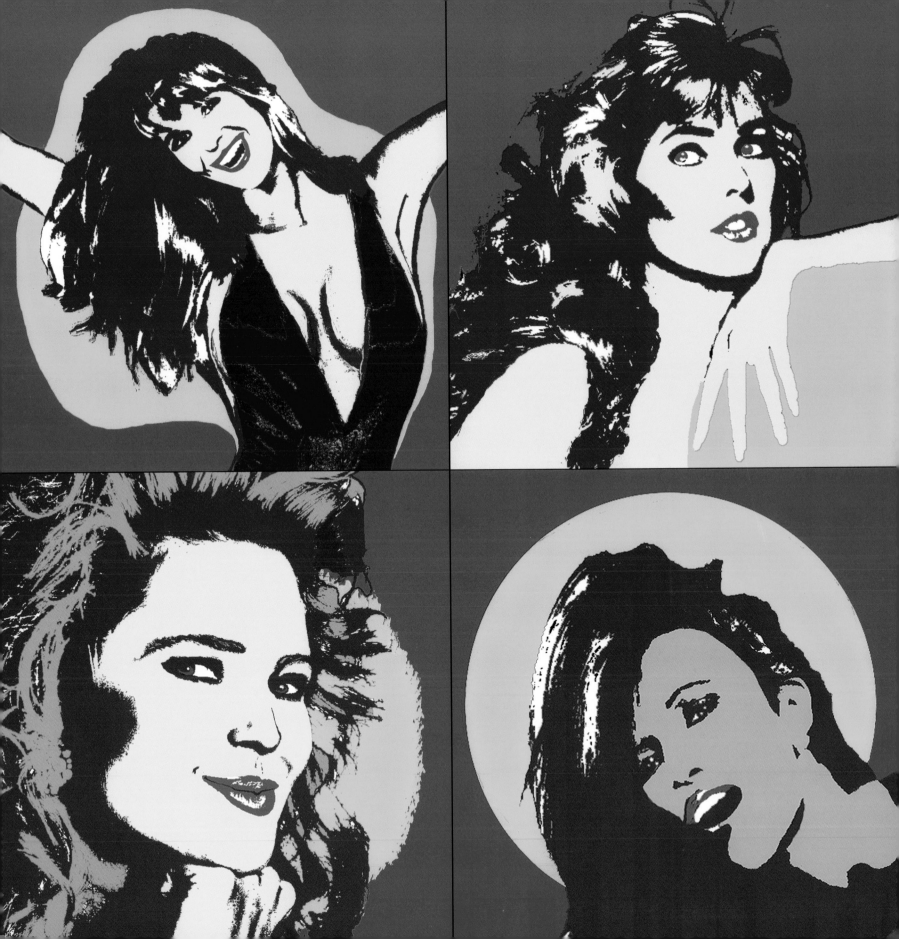

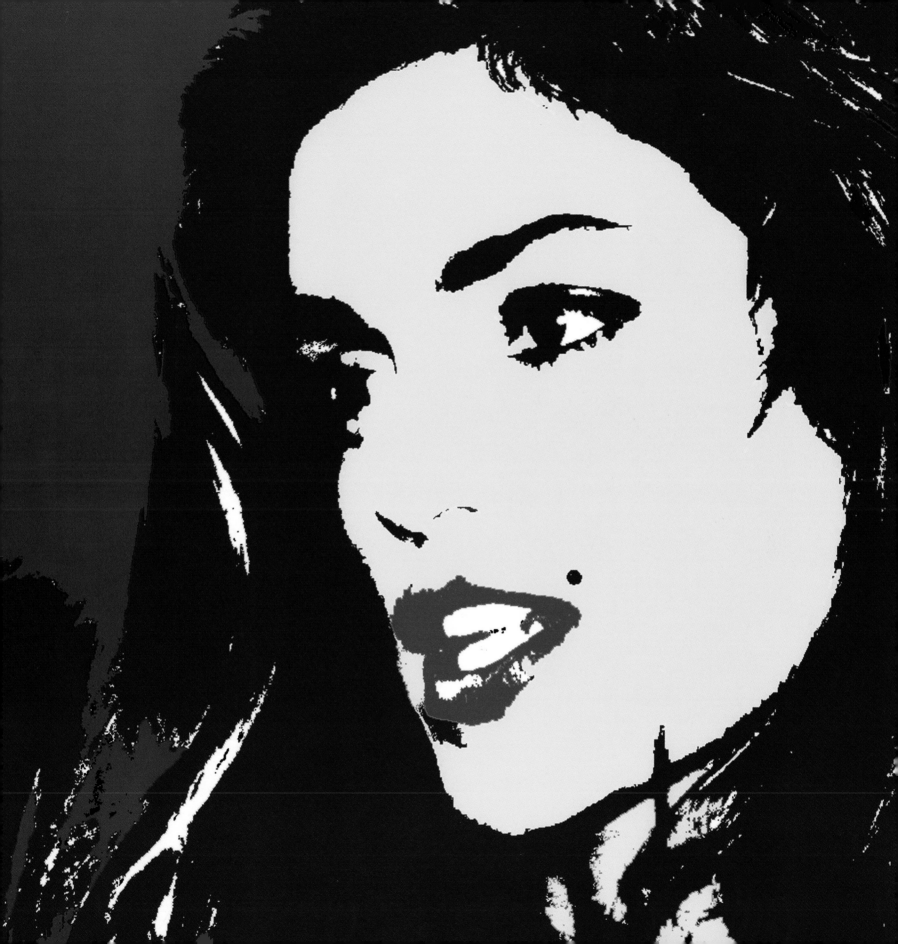

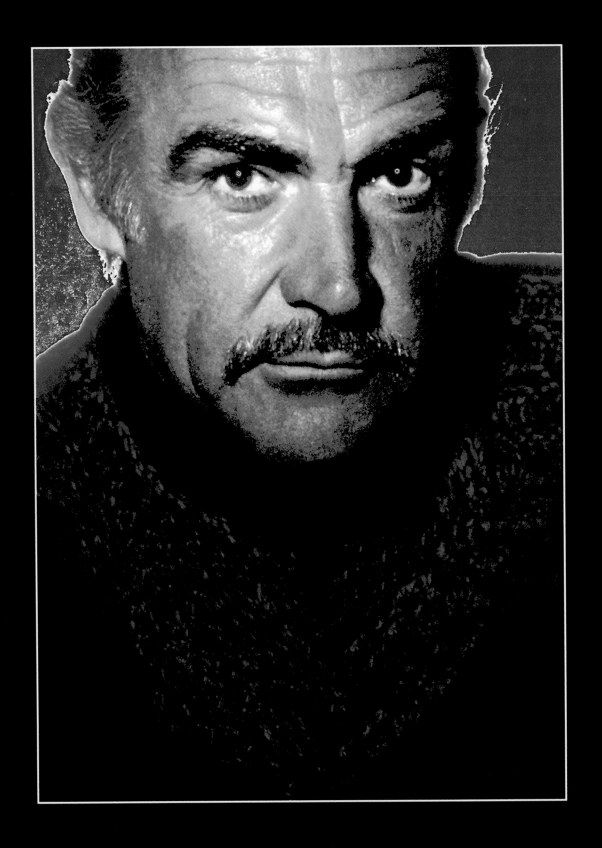

OPPOSITE: SEAN CONNERY is extremely impatient if he perceives incompetence, but exceedingly generous and tolerant when he finds genuine need. He speaks with an eloquent Scottish accent, and laughs with a deep, powerful resonance that goes to the roots of the earth.

ABOVE: MARGAUX HEMINGWAY is a tall, husky-voiced beauty, whose star shone brightly for a very brief time around twenty years ago. Sweet and lovable, she recently lamented of one of her ex-husbands: "I'm afraid that he loved my name more than he loved me."

ELIZABETH TAYLOR was the essence of glamour that evening, as she prepared to launch into the night and attend the Paris Opera. Arrangements had begun the day before with Alexandre, the grand coiffeur of the season. Jewelry had been flown in specially from London by private courier. Wearing her favorite fragrance of that time, Jungle Gardenia, Elizabeth paused for the half-second it took me to photograph her, lifting her head into a regal stance against the shimmering candlelight.

OVERLEAF LEFT: GEENA DAVIS, at first appearance, may seem goofy and tomboyish, but on the big screen she is unquestionably professional and one of today's sexiest stars.

BELOW: KATHARINE ROSS posed for me in the middle of a road going nowhere, simply because I thought it would make an interesting picture. I asked her, she trusted me, and she sat. Now that the computer has been added to the equation and the variables greatly expanded, the reasons why a picture is shot a certain way seem even more elusive.

ISABELLA ROSSELLINI is not someone whom I can say I truly know. Negotiations leading up to my photographing her had been unclear, so when I showed up I was given only limited, halfhearted access. Still, it's remarkable what can be done with the combination of the computer and that beautiful face.

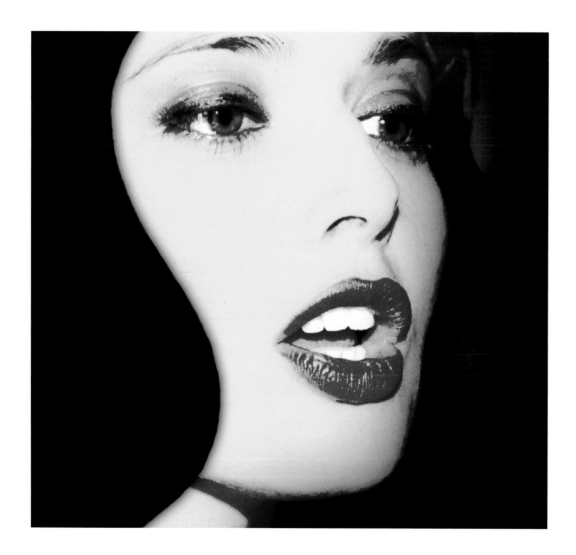

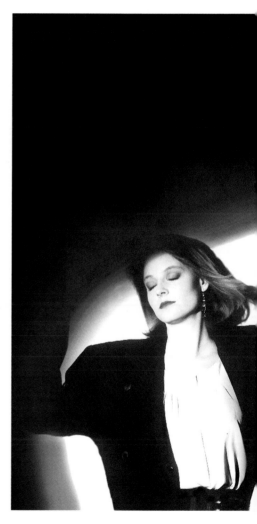

JODIE FOSTER's pure, straightforward energy has allowed her to remain unspoiled by her success. I am sure that in the future she will be remembered as one of the greatest talents of her generation.

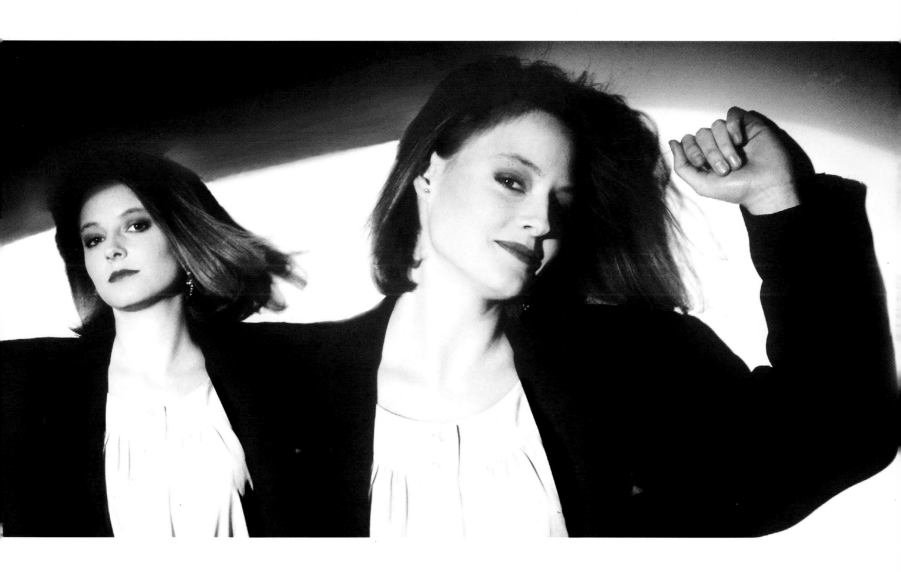

JANE FONDA holding her daughter Vanessa: this is, for me, a quintessential, timeless image of motherhood.

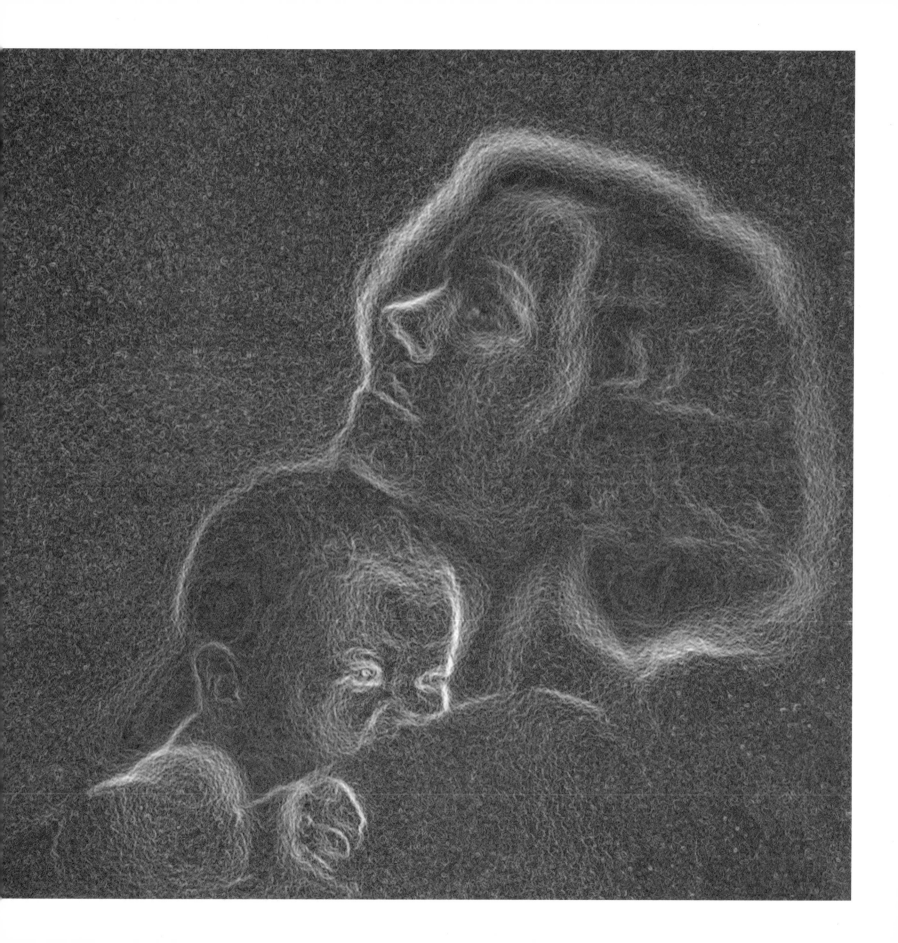

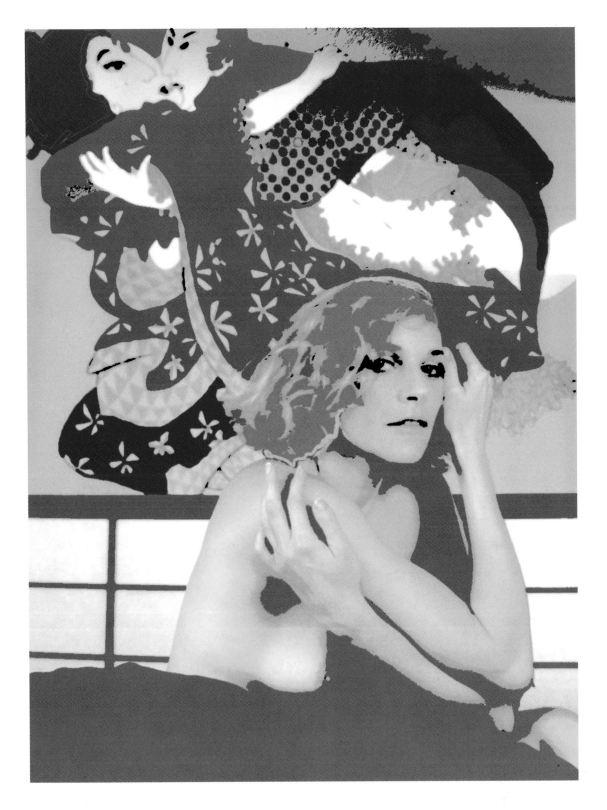

HELEN SHAVER sat on the edge of her bed, sending out wonderfully erotic vibrations. It is difficult to explore, and still harder to explain, what sets off these sensations within a man or a woman. As a photographer, I always hope to capture these feelings through the lens, so others might respond as I have.

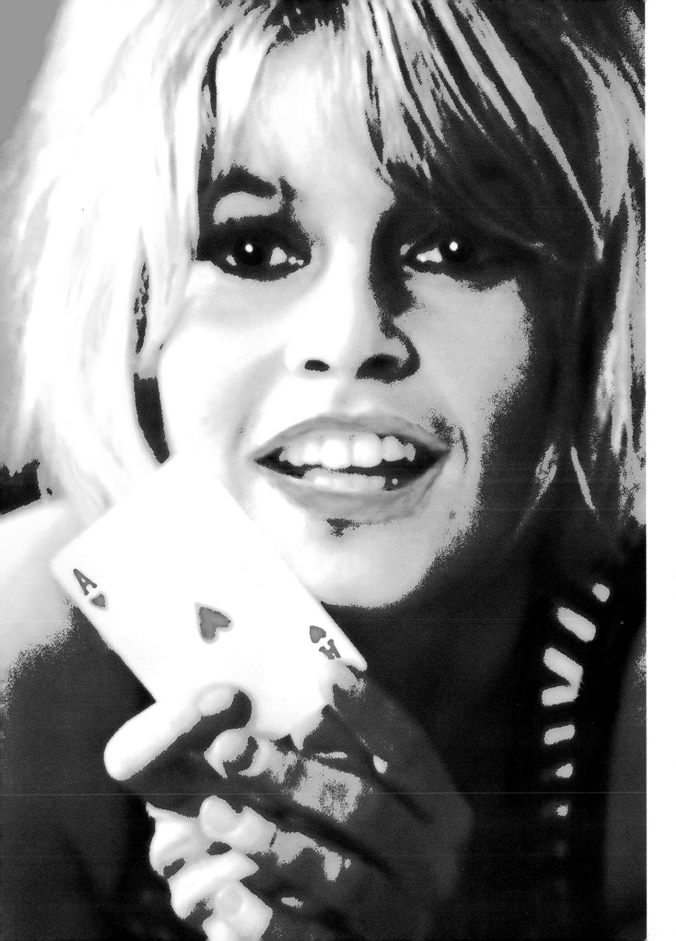

BRIGITTE BARDOT was, along with Charles de Gaulle, one of the greatest French luminaries of the '50s and '60s. Although I never knew the general, I did hang out with Bardot. Spending time with B.B. was about laughter and games, endless games. We danced and played and, if it was deemed *le moment*, took a few photos. I must confess: it was fun.

AUDREY HEPBURN, with her innocent, schoolgirl charm, was an alluring figure for me in the Paris of the mid-60s. Was it the lovable Audrey of *Funny Face* who played with me and the camera, or someone who rarely showed her true self?

Recently, a young woman who saw this image commented: "What I like about this is that it brings to my generation something that we can relate to, but also tells me how people back then must have felt about her."

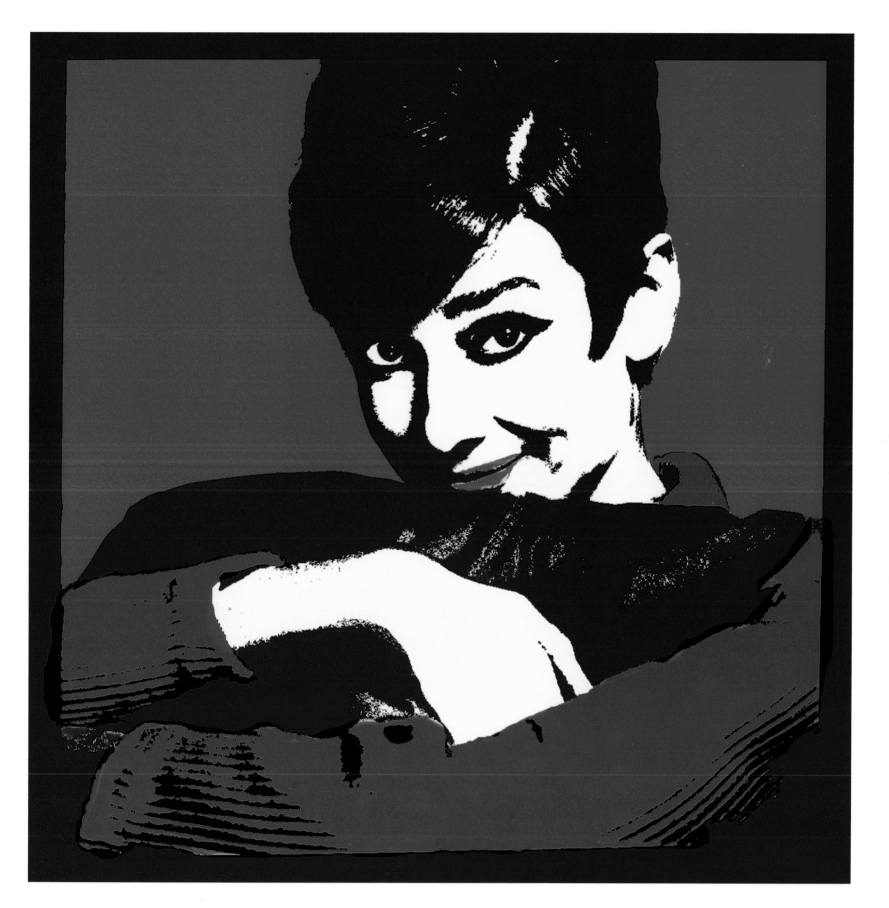

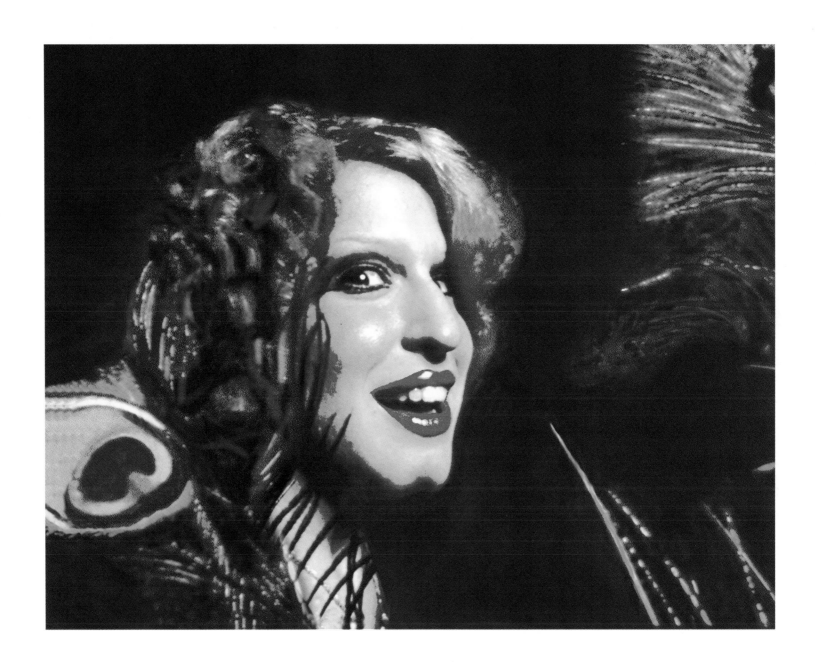

BETTE MIDLER was fun, bawdy, and a flirt back in the
days when she lived in New York's Greenwich Village.

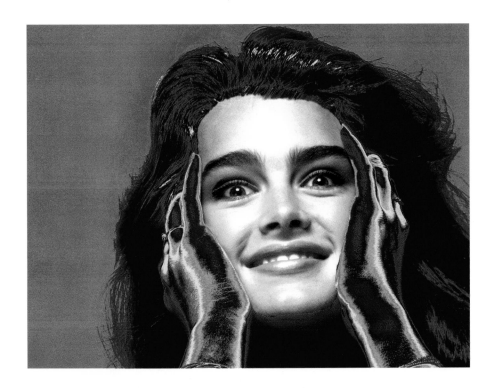

TOP LEFT: BROOKE SHIELDS, at sweet sixteen, was the flawless face of the early '80s.

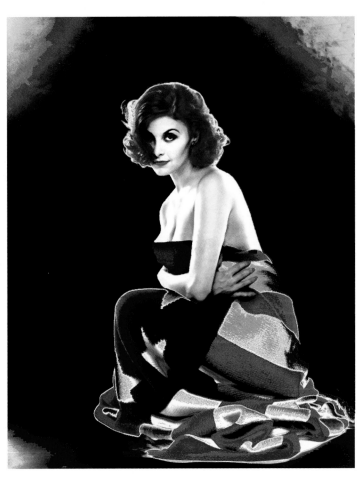

ABOVE: SHERILYN FENN let us in on all those dark secrets in *Twin Peaks*, but the day I photographed her, the press agent preferred she not reveal too much.

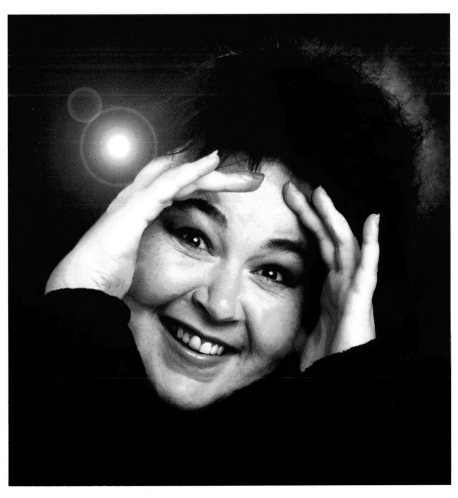

BOTTOM LEFT: ROSEANNE ARNOLD was just starting her television career at the time I met her. Though her comic appeal was plain to see, who would have imagined she would emerge as one of the toughest and most powerful women in television?

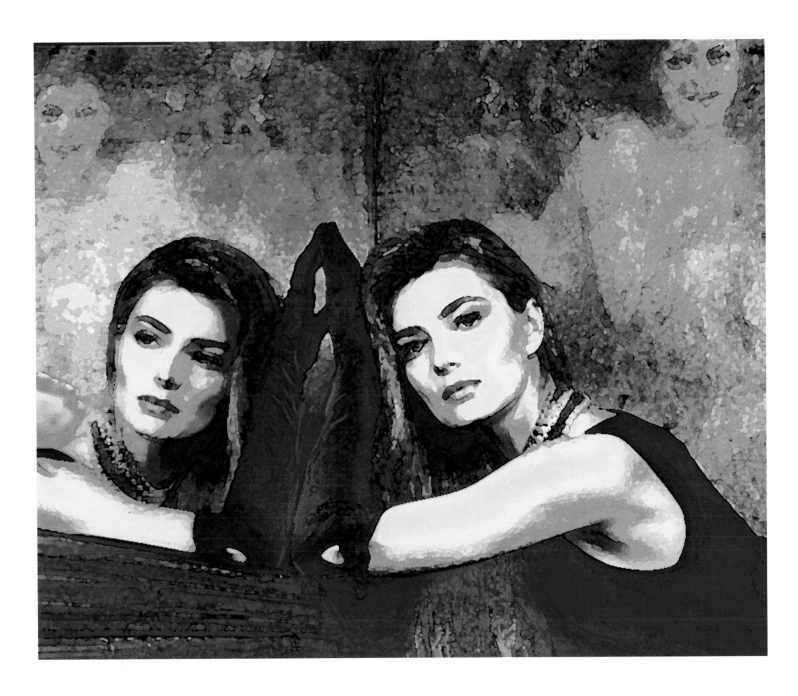

ABOVE: PAULINA PORIZKOVA, the top *mannequin* of the moment, languidly melted into the ambiance of the Café des Artistes, suggesting a different time and place than present-day West Sixty-seventh Street in New York City.

OPPOSITE: GOLDIE HAWN often plays the bright-eyed, giggling bimbo, but in reality she is shrewd and decisive. The last time I photographed her, she laughingly commented: "We've been doing this for a long time now, but at least we're both still working!"

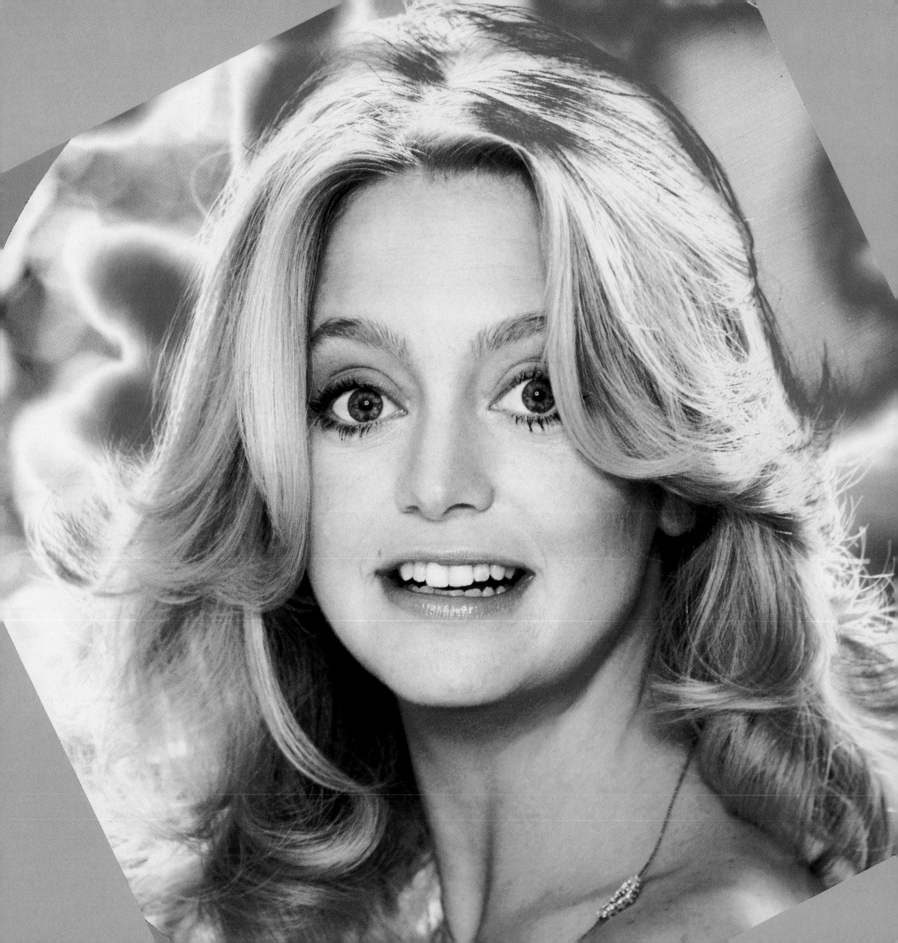

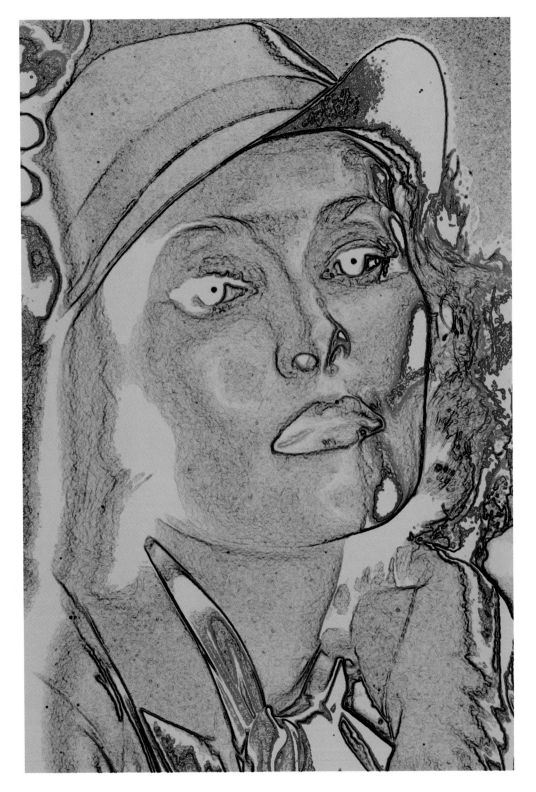

FAYE DUNAWAY has always lived her roles. This computer-modified sketch comes from 1974, when she played opposite Jack Nicholson in *Chinatown*.

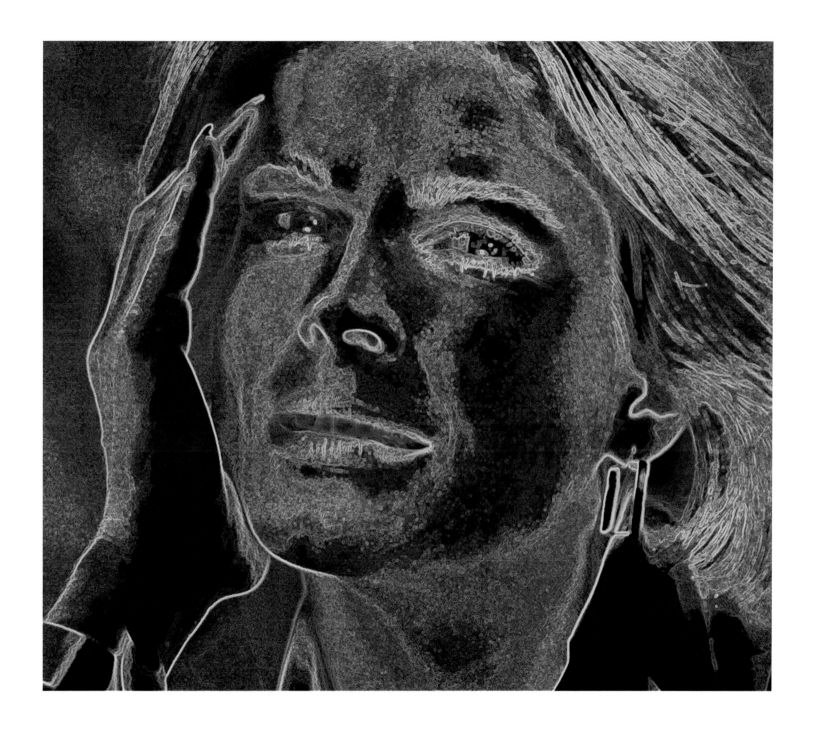

CANDICE BERGEN was a photographer and a writer
doing occasional movie parts when I first knew her.
Today millions laugh at her on *Murphy Brown*.

PETER O'TOOLE is a man with exceptional charisma. At the time this picture was taken, he was the bright, good-looking star of *Lawrence of Arabia*. Perhaps more than any other photograph I have modified with the computer, this image satisfies my sense of Peter as I knew him.

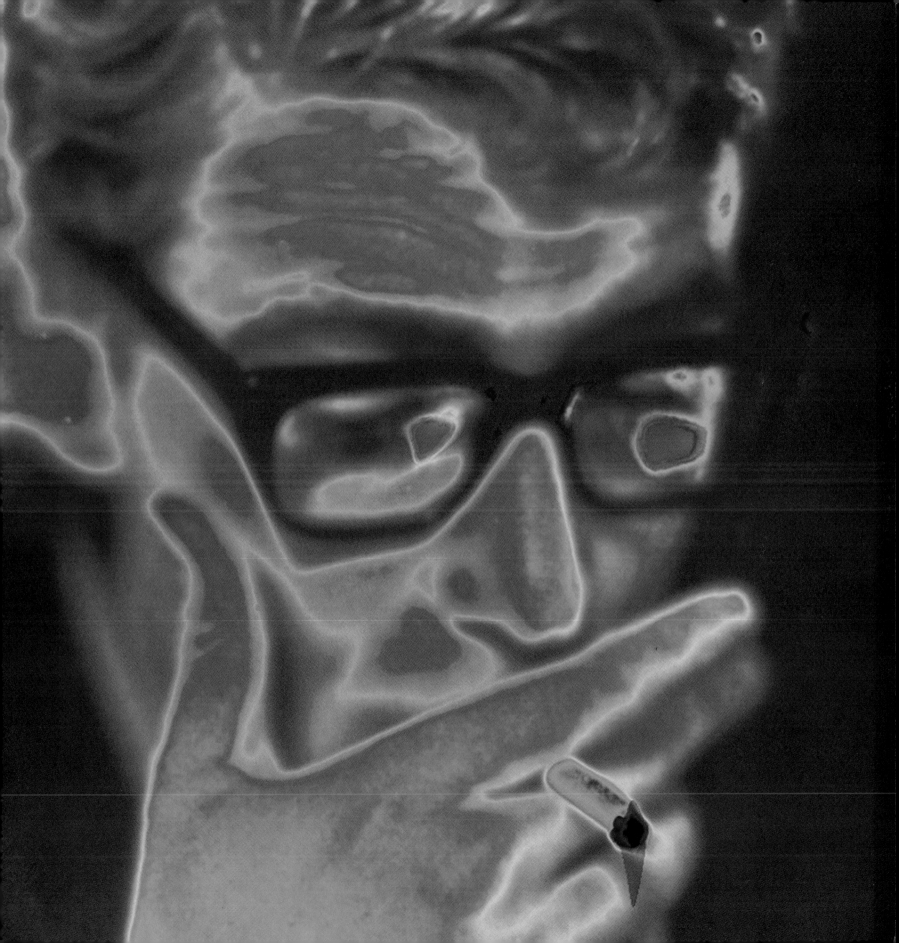

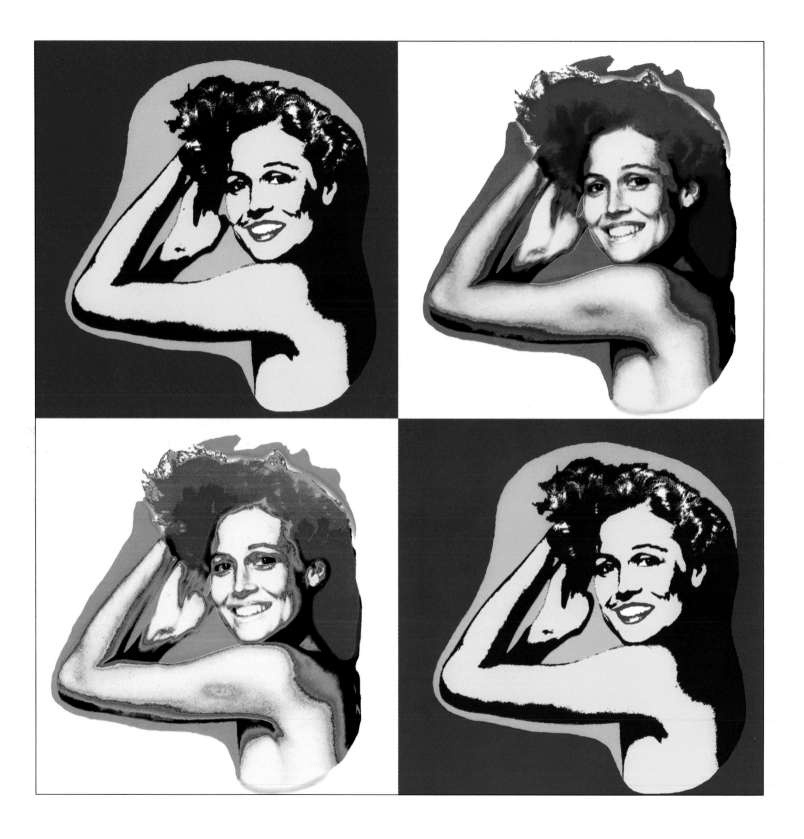

SIGOURNEY WEAVER made a film in the mid-80s titled *Une Femme ou Deux (One Woman or Two)*, so here's my '90s presentation of *Une Femme ou Quatre*.

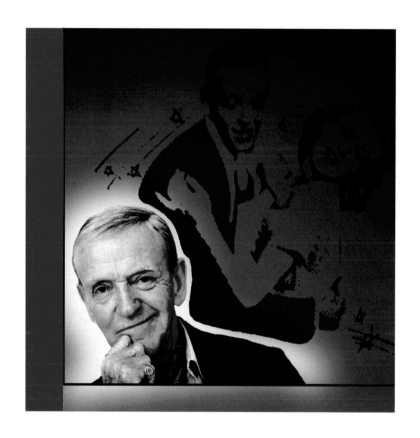

FRED ASTAIRE was in his early eighties when I took his picture. Secretly, I had hoped to capture him performing one more dance step, but after I cajoled him into position and asked, he looked up with a quiet smile and said: "I really don't dance anymore. I really don't!"

GENE KELLY was a key figure in shaping the golden age of the Hollywood musical. For most people, the song "Singin' in the Rain" conjures up warm, happy memories of a lighthearted Gene twirling on the big screen. On a personal level, I found him to be a true reflection of his screen image: an amazingly energetic and vibrant man!

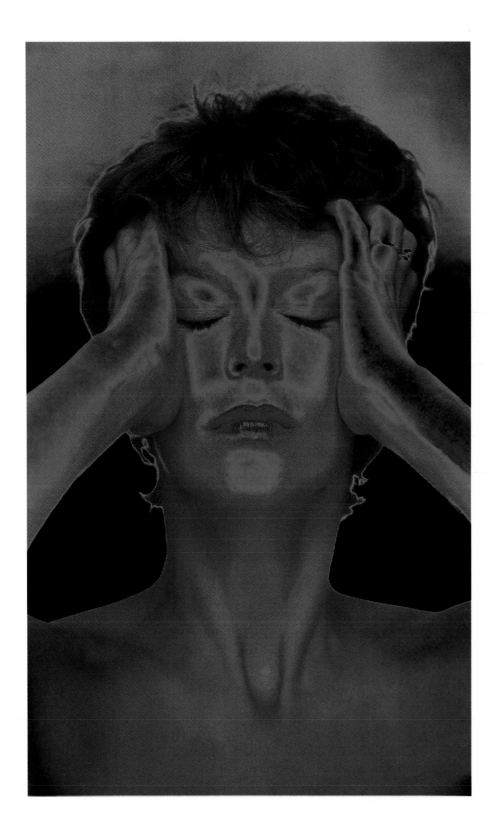

LEFT: JAMIE LEE CURTIS is lively, sexy, and always full of surprises.

OPPOSITE: JACQUELINE BISSET stepped out of an elevator on the arm of a friend, who announced with great bravado that she would be the next Brigitte Bardot. This was in swinging London in 1966. Now that she has made more than forty feature films, countless aspiring young actresses have hoped to become the next Jackie Bisset.

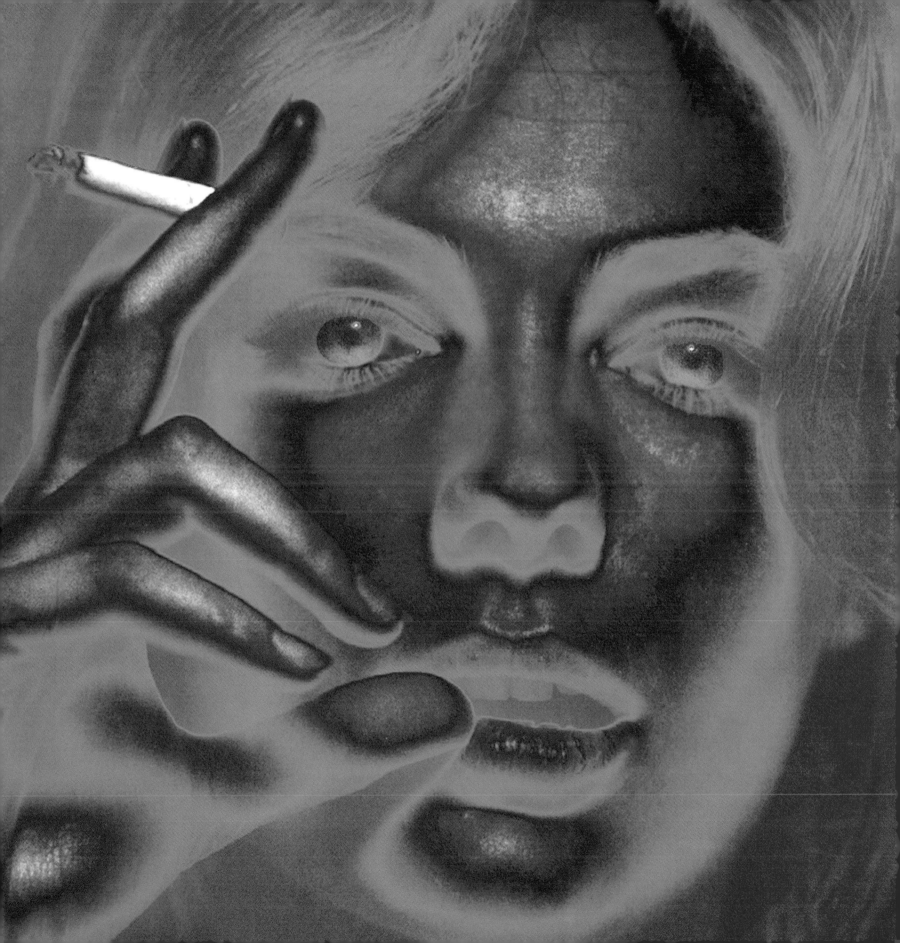

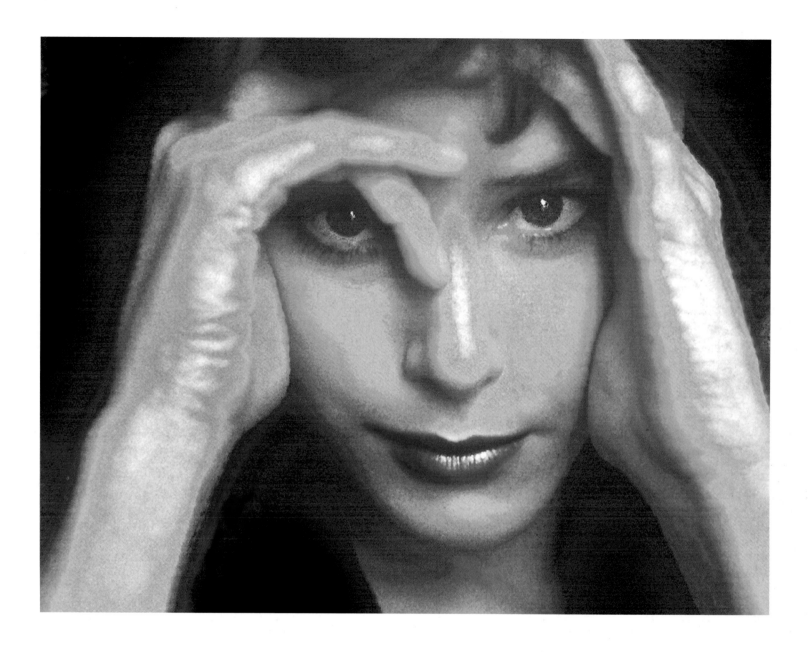

ABOVE: **DEBRA WINGER** had just received her Oscar nomination for *Terms of Endearment* when I photographed her for the first time. There was a sweet perfume of success in the air, and it felt as if we couldn't get close enough to each other. Energetic and seductive, she was full of ideas, and neither of us wanted the session to end.

OPPOSITE: **SHIRLEY MACLAINE** and I were both at the beginning of our careers when I took this picture of her as a sad clown. Having had the opportunity to modify it on the computer, I feel as though I have rediscovered a gold nugget.

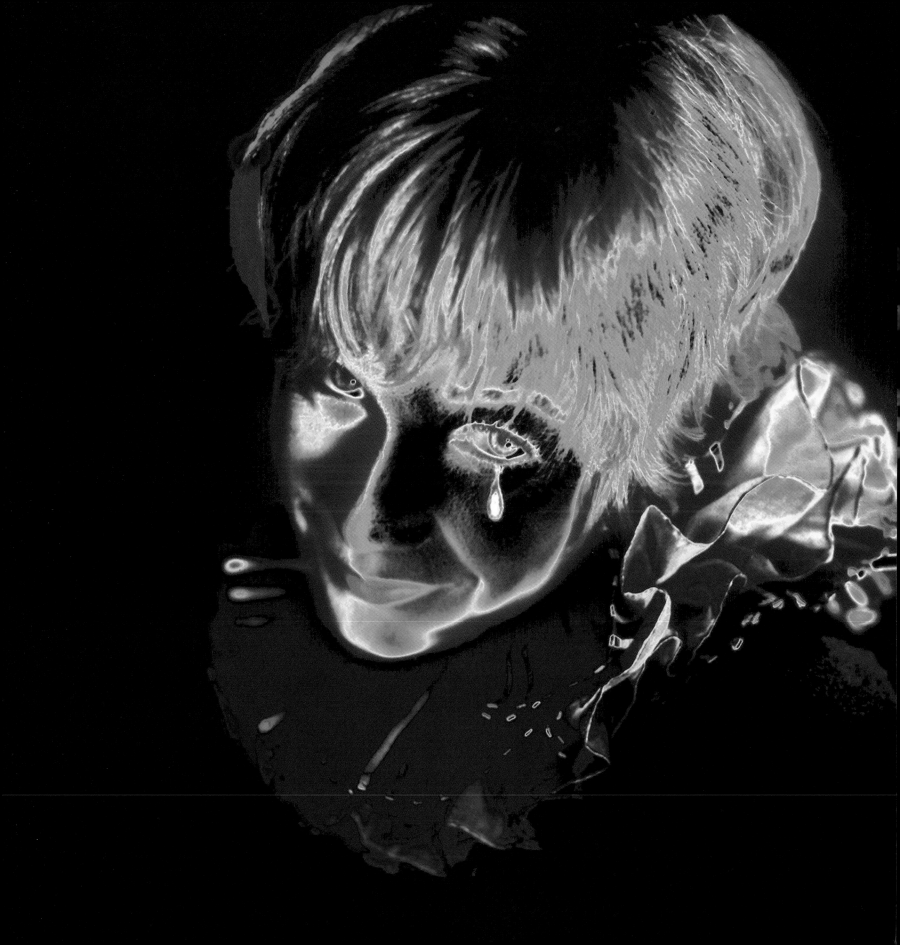

MARLENE DIETRICH, at age sixty, still possessed the same seductive ambiguity she had revealed as the saloon singer in *Destry Rides Again* and the Foreign Legionnaire's lover in *Morocco*. When I went to her apartment to plan our shoot, there was unmistakable electricity in the air. She sat on the floor, with those famous legs stretched out before her, and provocatively looked up, asking if I'd like to hear some of her records.

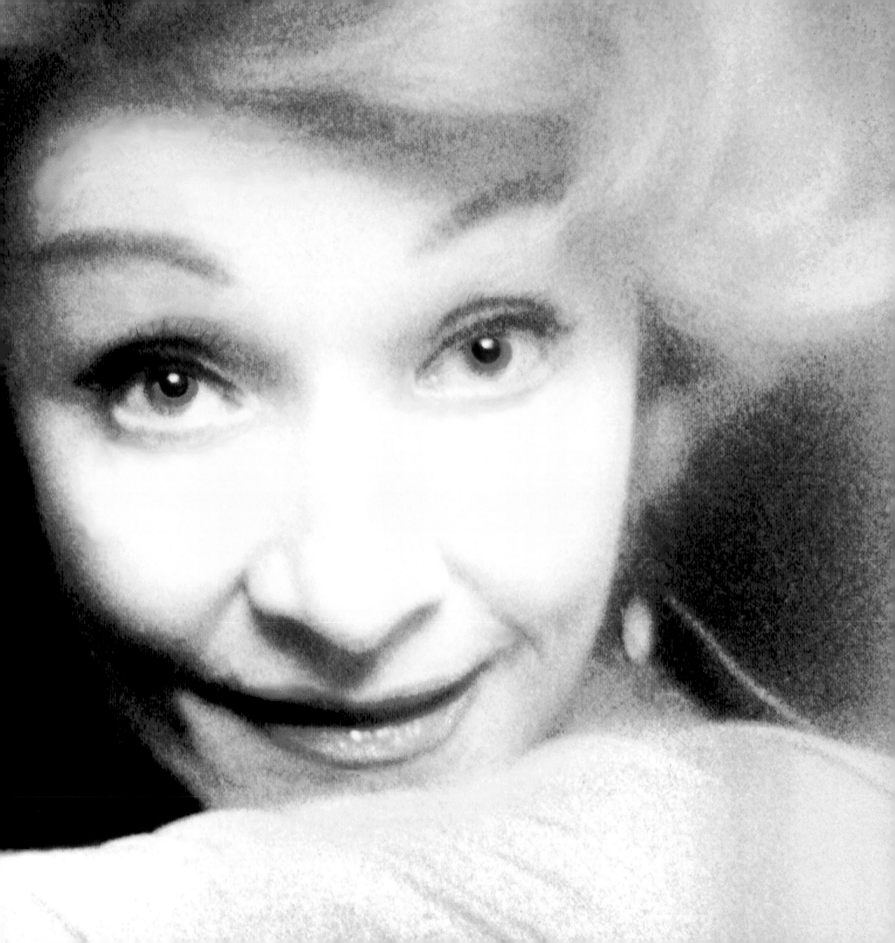

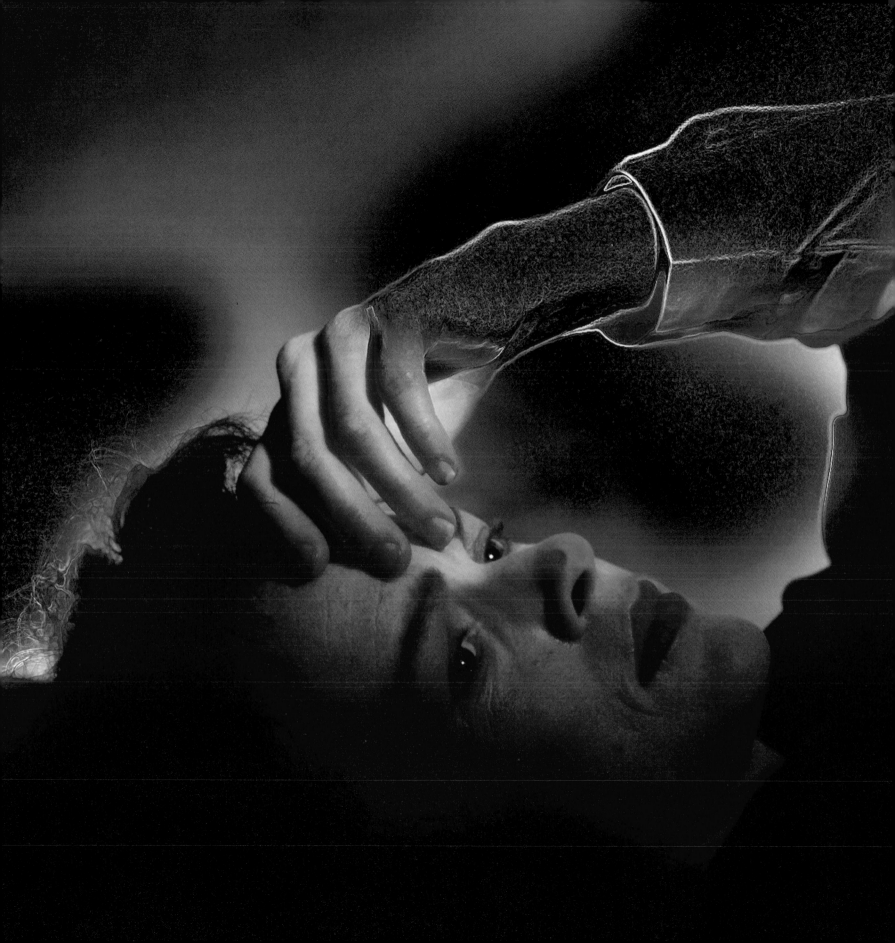

JUDY DAVIS is the Australian actress known for her brilliant, even savage, talent. She has been described as having the ability to anger and repulse you deeply in one moment, and have you crying for her the next.

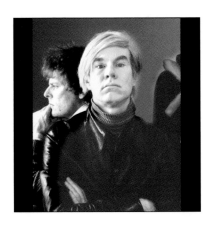

THE PLAYERS OUT OF COSTUME
Gallery of Original Photographs

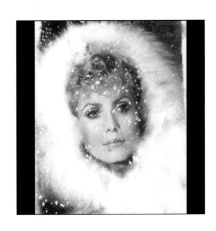

Jacket, pages 8, and 95
Andy Warhol
Hollywood 1969

Page 15
Catherine Deneuve
Vienna 1970

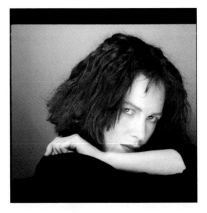

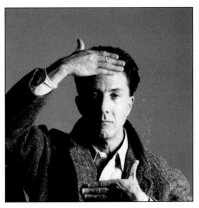

Endpages
Vendela
Hollywood 1992

Page 16
Dustin Hoffman
New York 1989

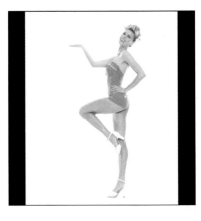

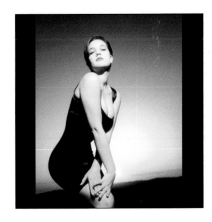

Pages 2–3 and 4–5
Judy Davis
Los Angeles 1989

Page 17
Drew Barrymore
Hollywood 1992

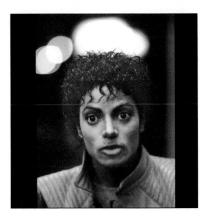

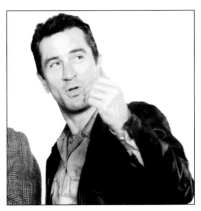

Page 8
Michael Jackson
Los Angeles 1983

Page 19
Robert De Niro
Las Vegas 1988

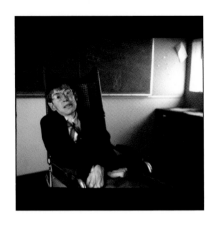

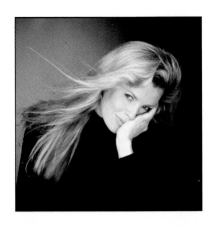

Pages 20 and 20–21
Stephen Hawking
Pasadena 1983

Pages 26–27
Kim Basinger
Hollywood 1989

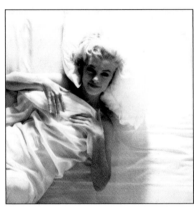

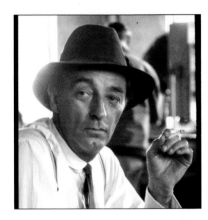

Page 23
Marilyn Monroe
Hollywood 1961

Page 28
John Wayne
Burbank 1976

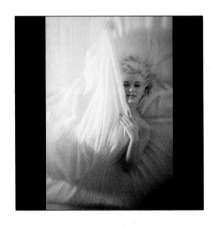

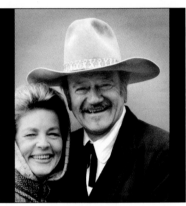

Page 24
Marilyn Monroe
Hollywood 1961

Page 29 top left
Robert Mitchum
Dingle, Ireland 1969

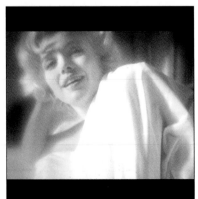

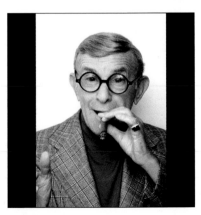

Page 25
Marilyn Monroe
Hollywood 1961

Page 29 top right
George Burns
Beverly Hills 1978

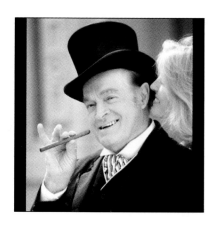

Page 29 bottom right
Bob Hope
Los Angeles 1976

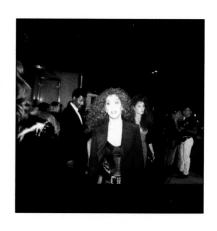

Page 32–33
Cher
Los Angeles 1991

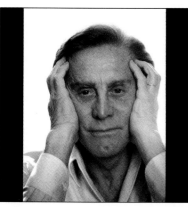

Page 29 bottom left
Kirk Douglas
Beverly Hills 1988

Pages 34 and 35
Michael Jackson
Los Angeles 1983

Page 30
Warren Beatty
Vancouver 1971

Pages 36–37
Out of Africa
Meryl Streep and
Robert Redford
Kenya 1985

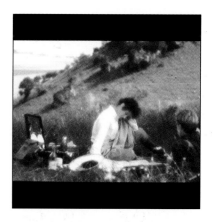

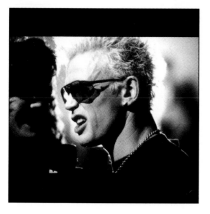

Page 31
Billy Idol
Los Angeles 1991

Page 38
*Those Magnificent Men in
Their Flying Machines*
Newcastle, England
1964

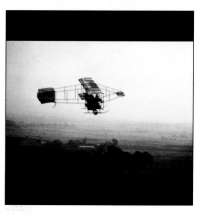

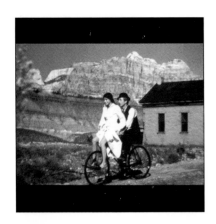

Page 38
Butch Cassidy and the Sundance Kid
Katharine Ross and Paul Newman
St. George, Utah 1968

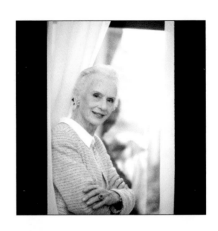

Page 44
Jessica Tandy
New York 1990

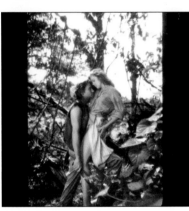

Page 39
Romancing the Stone
Michael Douglas and Kathleen Turner
Mexico 1983

Pages 40–41
The Charge of the Light Brigade
Ankara, Turkey 1967

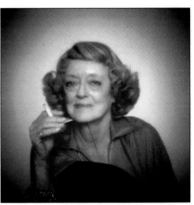

Page 45
Bette Davis
Hollywood 1979

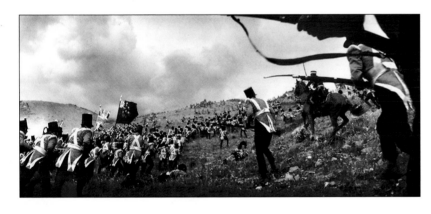

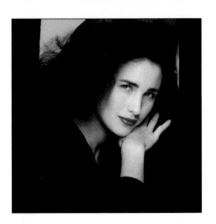

Page 46
Andie MacDowell
New York 1987

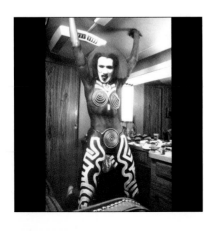

Pages 42–43
Grace Jones
and Keith Haring
Los Angeles 1986

Page 48 top left
Elle Macpherson
New York 1986

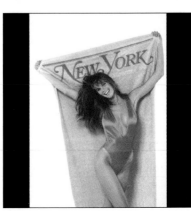

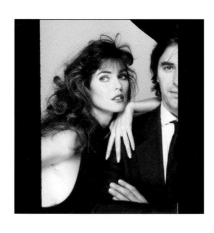

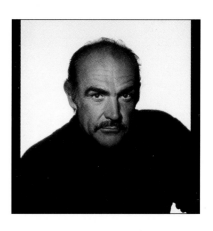

Page 48 top right
Carol Alt
New York 1987

Page 50
Sean Connery
Hollywood 1983

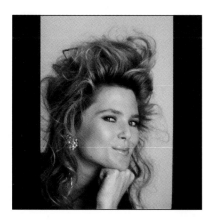

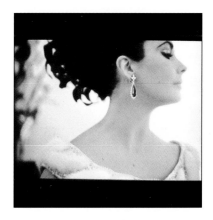

Page 48 bottom right
Iman (in back)
New York 1987

Page 51
Margaux Hemingway
Santa Monica 1979

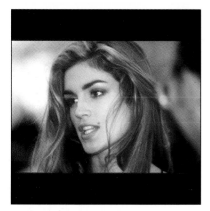

Page 48 bottom left
Christie Brinkley
New York 1982

Pages 52–53
Elizabeth Taylor
Paris 1963

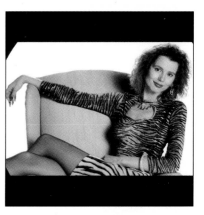

Page 49
Cindy Crawford
Los Angeles 1991

Page 54
Geena Davis
Burbank 1988

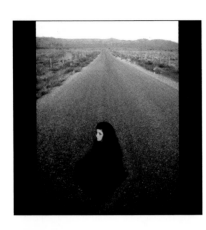

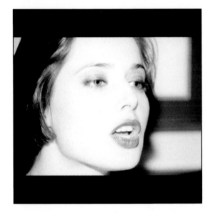

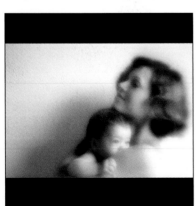

Page 55
Katharine Ross
St. George, Utah 1968

Page 56
Isabella Rossellini
New York 1983

Pages 56–57
Jodie Foster
Hollywood 1986

Pages 58–59
Jane Fonda with daughter
Vanessa
Malibu 1969

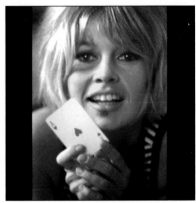

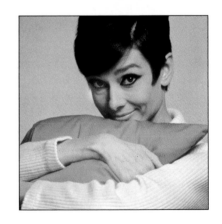

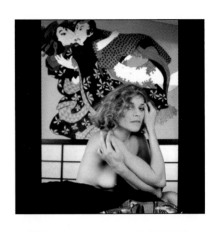

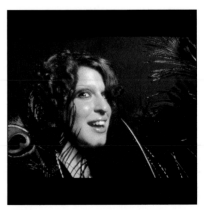

Page 60
Helen Shaver
Hollywood 1986

Page 61
Brigitte Bardot
Almeria, Spain 1965

Page 63
Audrey Hepburn
Paris 1964

Page 64
Bette Midler
New York 1972

Page 65 top left
Brooke Shields
New York 1981

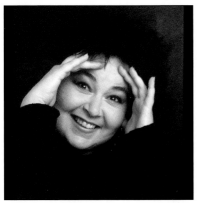

Page 65 bottom left
Roseanne Arnold
Hollywood 1988

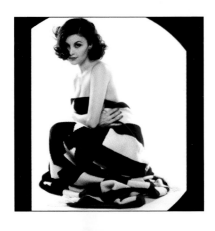

Page 65 right
Sherilyn Fenn
New York 1990

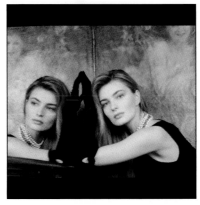

Page 66
Paulina Porizkova
New York 1990

Page 67
Goldie Hawn
Hollywood 1978

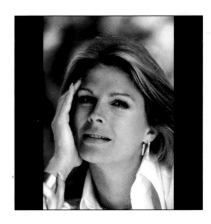

Page 68
Faye Dunaway
Los Angeles 1974

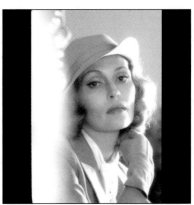

Page 69
Candice Bergen
Beverly Hills 1977

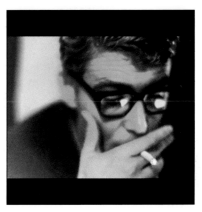

Pages 70–71
Peter O'Toole
London 1964

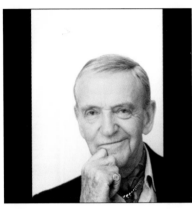

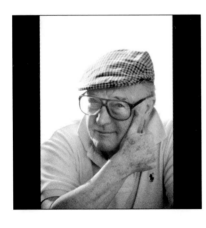

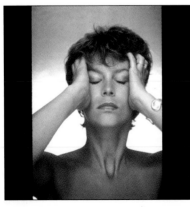

Page 72
Sigourney Weaver
Hollywood 1979

Page 74
Fred Astaire
Beverly Hills 1979

Page 75
Gene Kelly
Beverly Hills 1987

Page 76
Jamie Lee Curtis
Hollywood 1983

Page 77
Jacqueline Bisset
London 1968

Page 78
Debra Winger
Hollywood 1984

Page 79
Shirley MacLaine
Hollywood 1961

Pages 80–81
Marlene Dietrich
New York 1961

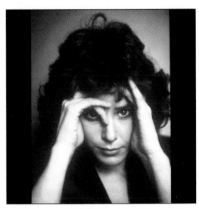

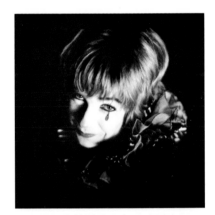

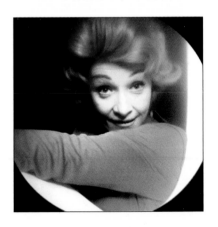

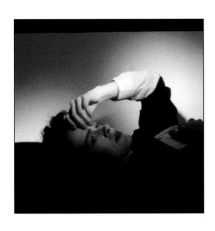

Pages 82–83
Judy Davis
Hollywood 1989

Page 96
Vendela
Hollywood 1992

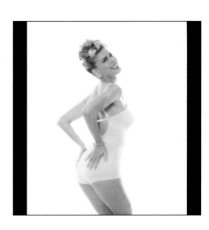

Producer's Note

Icons was created and produced using entirely digital technology. The page layouts were designed by Nai Chang on Apple Macintosh computers using QuarkXPress software and combined with text set in Adobe Futura Light and Futura Book. The text was edited by Hiro Clark of Welcome Enterprises and copyedited by Robin Jacobson of Fulcrum Media Services.

All manipulated images provided by Douglas Kirkland, including the cover and endpages, were adjusted and transformed into the four process colors (black, cyan, magenta, and yellow) in Adobe Photoshop software on Macintosh computers. These files were integrated with the page layout files and sized for output in QuarkXPress. Images in the gallery section (pages 85–93) were left as raw RGB files (red, green, blue, or standard image file format), and separated at output time on the fly via the Kodak Prophecy Color Publishing System, a Sun Microsystems–based color correction and output management system. The entire book was output at 175 lines per inch. All images were sampled at 1.5 times the screen frequency, or 262 dots per inch.

Pages were output from QuarkXPress to infrared lithographic film on a Tegra Varityper 6000 imagesetter using ESCOR (Enhanced Super Cell Open Rosette) screening technology. Instead of working at the level of single halftone dots, as most digital systems do, ESCOR groups halftone cells into supercells with open-centered rosettes. Looking under a loupe at any page of *Icons*, one can see how this process eliminates ink contamination and incorrect overlapping of dots. Using open-centered rosettes also compensates for any minor registration problems which, in dot-centered output, might cause moiré patterns. Color proofs were made directly from the lithographic, plate-ready film with the Kodak Contract Color Proofing System, which utilizes colored laminates to simulate each of the four process colors.

Kathy Migliozzi and Marion Finkel at the Center for Creative Imaging resized and separated the manipulated images. The use of the Varityper 6000 on this project was made possible by Barry Weiss and Sue Webb of Varityper, Inc. The book was separated and proofed at High Resolution Inc. in Camden, Maine, by Peter Koons, Sandy Soards, James DiLorenzo and Glenn Fleishman.

ACKNOWLEDGMENTS

Icons would not exist without the Center for Creative Imaging in Camden, Maine. Specifically, I want to thank Ray DeMoulin, Director of the Center, for his friendship and total support on this as well as previous projects; and Joan Rosenberg, Director of Special Events for the Center, for the unwavering enthusiasm and energy she has shown throughout.

Additionally, I am grateful for the contributions of Jim Lanahan and Apple Computer, who believed in this project from the start, and Claire Barry of SuperMac Technologies.

This work would also not have occurred without the nurturing help of my dear friend Eliane Laffont of Sygma. Eliane saw the work through to fruition.

In the technical areas, Mike Shaw always saved me when problems cropped up, as did the many individuals at ZZYZX and Samy's Camera in Los Angeles.

Finally, I want to thank Judith Thurman, who taught me something about writing, and Nancy Griffin, who helped me compose the introduction.

—DK

OPPOSITE: ANDY WARHOL
OVERLEAF: VENDELA

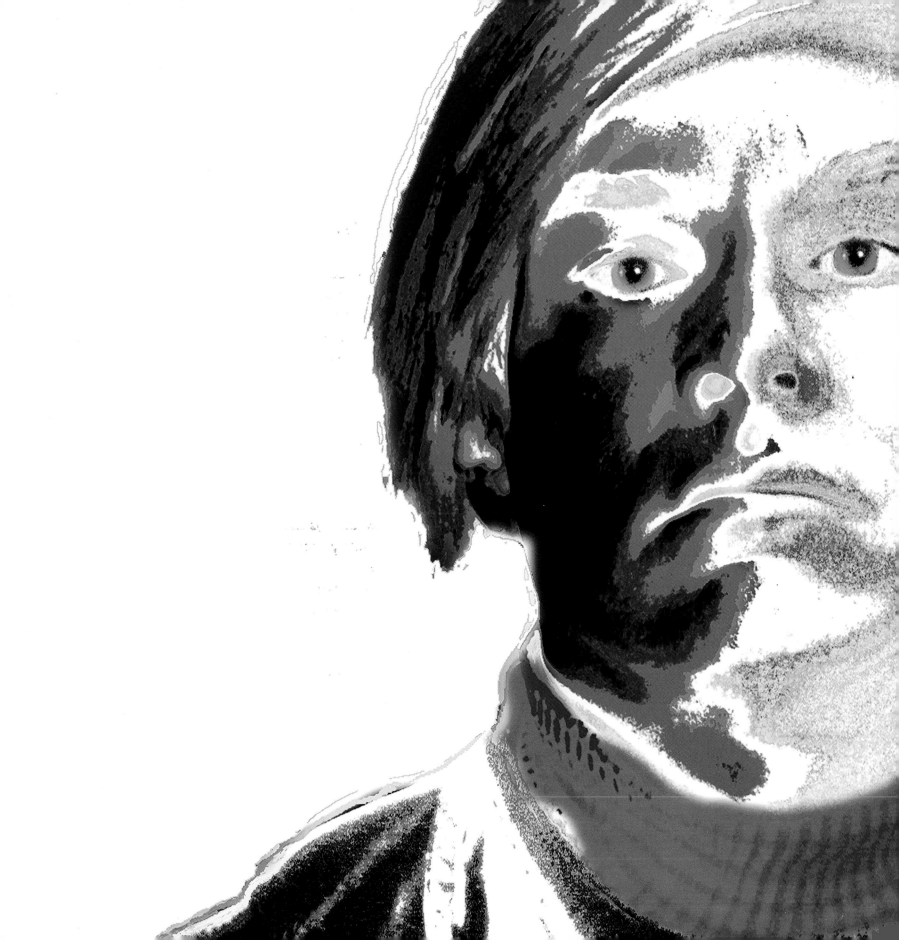